# IMAGES
## of America

# THE GAS BOOM OF
## EAST CENTRAL INDIANA

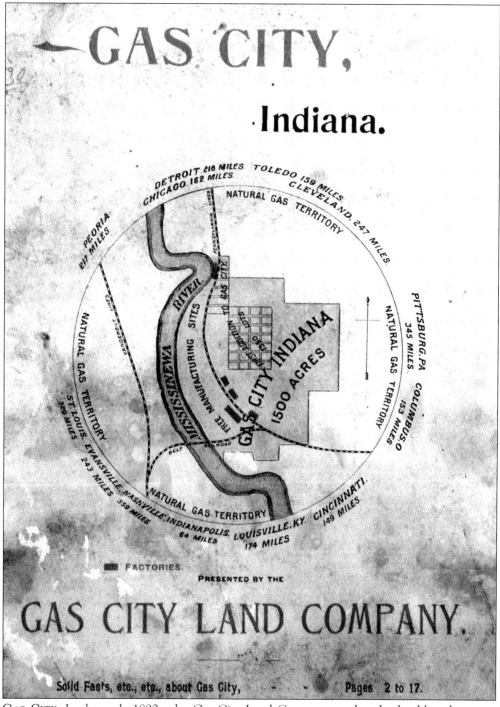

GAS CITY. In the early 1890s, the Gas City Land Company produced a booklet, the cover of which is seen here. Such booklets were issued in hopes of attracting industrialists. They highlighted the convenient location of the particular town, its amenities, and the abundant supply of free natural gas. (Courtesy Gas City Museum.)

IMAGES
*of America*

# THE GAS BOOM OF EAST CENTRAL INDIANA

James A. Glass and David Kohrman

Copyright © 2005 by Minnetrista Cultural Center Inc.
ISBN 978-0-7385-3963-8

Published by Arcadia Publishing
Charleston, South Carolina

Printed in the United States of America

Library of Congress Catalog Card Number: 2005927546

For all general information contact Arcadia Publishing at:
Telephone 843-853-2070
Fax 843-853-0044
E-mail sales@arcadiapublishing.com
For customer service and orders:
Toll-Free 1-888-313-2665

Visit us on the Internet at www.arcadiapublishing.com

# Contents

| | | |
|---|---|---|
| Acknowledgments | | 6 |
| Introduction | | 7 |
| 1. | The Discovery of Natural Gas | 9 |
| 2. | Muncie | 17 |
| 3. | Anderson | 33 |
| 4. | Kokomo | 41 |
| 5. | Marion | 53 |
| 6. | The Smaller Communities | 67 |
| 7. | The Second Wave | 79 |
| 8. | Boom Goes Bust | 91 |
| 9. | Legacies of the Gas Boom | 97 |

# Acknowledgments

The authors would like to thank the following individuals and organizations, whose help greatly contributed to the success of this book. The Minnetrista Cultural Center provided funding for the project, and we wish to thank the staff for their support, especially former president and CEO Owen Glendening, interim president and CEO Karen Vincent, vice president of programs Rebecca Holmquist, curator of industrial and business history Dick Cole, and archivist Susan Smith. Many other individuals and local institutions assisted us in locating images and information, including Bonnie Van Kley and Gail Leiter of the Howard County Historical Society; Dick Bowman of the Madison County Historical Society; Patty Chapman of the Gas City Museum; and the staffs of the Indiana State Library, the Elwood Public Library, the Gas City Public Library, the Fairmount Historical Museum, and Archives and Special Collections at Ball State University's Bracken Library. The following publications were used in this book:

*Frank Leslie's Illustrated.* Editions of January 19, 1889; May 4, 1889; November 22, 1890; and July 4, 1891.
Hardesty, J. O. *What Everybody Wants to Know about Anderson, Indiana.* Anderson, IN: Bulletin Publishing Company, 1891.
*Kokomo: Past, Present, Future.* Kokomo, IN: Kokomo Enterprise Company, 1893.
*Marvelous Marion: The Queen City of the Indiana Gas Belt.* Marion, IN: Marion Leader, 1892.
*Muncie, Indiana: The Natural Gas City of the West.* Muncie, IN: Muncie Natural Gas Land Improvement Company, 1889.
*Muncie of Today.* Muncie, IN: Muncie Times, 1895.

# Introduction

East-central Indiana is known for its mixture of agricultural production, medium-sized industrial cities, and small towns with early-1900s architecture. The production of corn, cereal grains, and livestock in the region dates back to the beginnings of settlement, before the Civil War. The industrial characteristics were brought about by one of the great booms of the late 19th century in the Midwest: the discovery of natural gas. The eruption of real-estate speculation, industrial development, commercial expansion, and population growth transformed a 2,500-square-mile portion of the state from a landscape of farms, forest, and agricultural villages into a territory dominated by cities and boom towns, each teeming with factories, neighborhoods, and commercial districts. Between 1886 and 1901, an 11-county area in the east-central section of the state became one of the leading centers of heavy industrial production in the country and the principal manufacturing region of Indiana.

Although gas ran out at the dawn of the 20th century, greatly diminishing the economic vitality and size of many towns, the principal cities created by the Gas Boom persevered and used the industrial foundation bestowed by natural gas to lure additional factories and commerce. In the smaller cities and towns of the area, the boom left a few factories, distinctive brick commercial business districts, and attractive residential neighborhoods.

Besides buildings, the Gas Boom has provided a wealth of images, artifacts, and information with which to tell its story. These images are the focus of this book. Throughout the Gas Belt, photographs were taken of individuals, locations, events, and occasionally gas wells. Highly detailed line drawings were published of the many sprawling factories and displays of gas flambeaux in booklets designed to attract industrialists. Maps showing each community's proximity to potential customers were another means of drawing investors. All of these sources offer a glimpse into the fabulous boom era.

This work is not intended to be an exhaustive study of the Gas Boom; rather, it is a survey of developments and trends that were widespread throughout the Gas Belt. It is our hope that this will serve as a catalyst for future projects and exhibits that will dig deeper into the story. For the purpose of this project, we have focused on the four largest cities of the boom—Muncie, Anderson, Kokomo, and Marion—as well as some of the smaller communities like Elwood, Gas City, and Fairmount.

# One

## THE DISCOVERY OF NATURAL GAS

In 1886, the discovery of the Karg well in Findlay, Ohio, signaled the end of the slow-paced agricultural life of east-central Indiana. Natural gas had previously been found in large quantities in western Pennsylvania and had revolutionized the iron, steel, and glass industries of Pittsburgh, as industrialists adapted their factories to use natural gas in place of the more expensive coal. The Karg well demonstrated that gas existed in substantial quantities in the Trenton limestone beneath northwestern Ohio, triggering a speculative frenzy as gas companies drilled and real-estate speculators drove up the prices of land in anticipation of factories locating in the new boom area. Within a short time, hometown investors in several Indiana communities also began to drill, anticipating gas in the large Trenton limestone belt that extended into the north-central portion of the state. It would not be long before one of the efforts paid off.

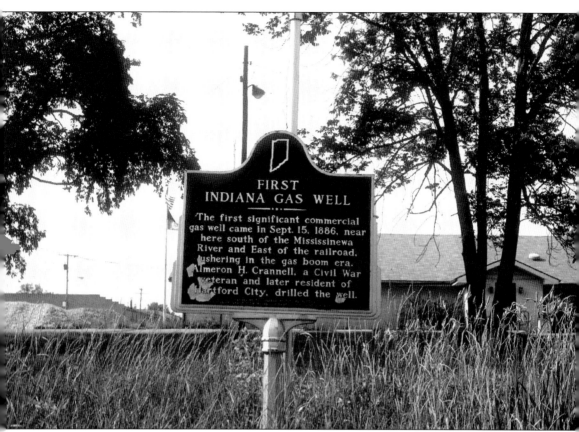

NATURAL GAS DISCOVERED AT EATON. In 1876, gas was first struck in Indiana at Eaton, a small town north of Muncie. However, this well was not exploited until word came of gas in Ohio. In October 1886, the first well in Indiana to produce a profitable supply of gas was drilled at Eaton. George W. Carter, a businessman from Eaton; William W. Worthington, superintendent of the Fort Wayne, Cincinnati, and Louisville Railroad; and state senator Robert C. Bell of Fort Wayne hired gas driller Almeron H. Crannell to sink the bore. Gas was struck at 922 feet below grade. The flame emitted by the well rose 10 feet and attracted crowds for many weeks. (Photograph by James Glass.)

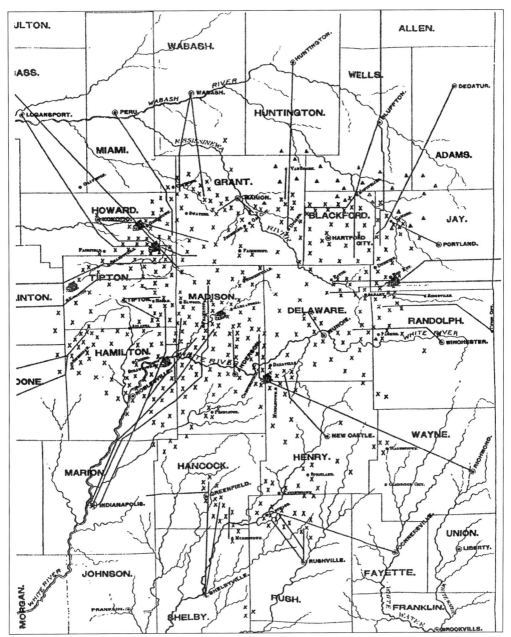

GAS BELT. This 1890s map of the Gas Belt shows the locations of the major gas wells. The initial territory in which gas was reported covered over 5,000 square miles. In 1892, the state supervisor of natural gas reported that the area in which profitable wells could be located embraced a still impressive 2,500 square miles. It was the largest gas field in the world at that time, larger than those of Pennsylvania and Ohio combined. (Courtesy Madison County Historical Society.)

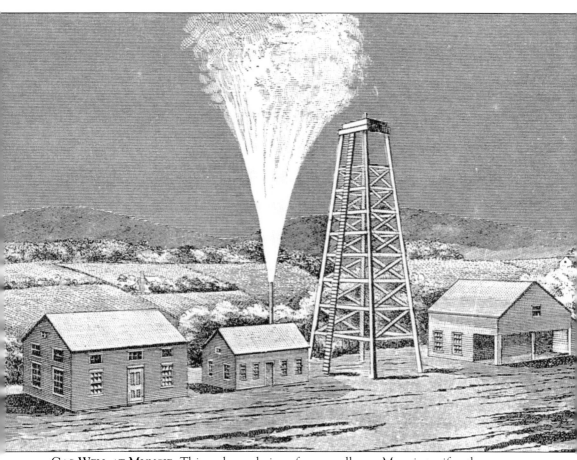

GAS WELL AT MUNCIE. This early rendering of a gas well near Muncie typifies the appearance of such facilities. The most prominent feature is the tall wooden derrick. This is surrounded by small wooden support structures, usually built quickly. The tall pipe next to the derrick is the telltale indicator of a gas well. The artist has included his best representation of escaping natural gas. (Courtesy Archives and Special Collections, Bracken Library, Ball State University.)

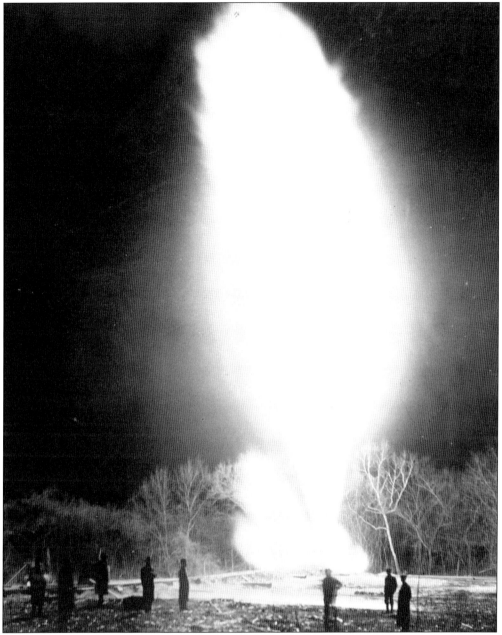

GAS WELL AT GAS CITY. Once a well was discovered, officials thought the best way to show off its output was to light it up. The resulting flame was known as a flambeau. This large flambeau was located at Gas City. (Courtesy Gas City Museum.)

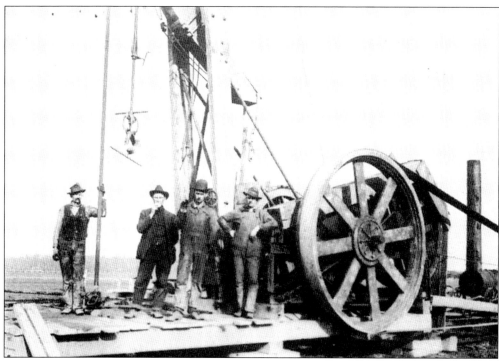

GAS WELL DRILLERS. Revealed in this photograph of a group of gas well drillers near Kokomo is the equipment required to drill for natural gas and oil in the late 19th century. (Courtesy Howard County Historical Society.)

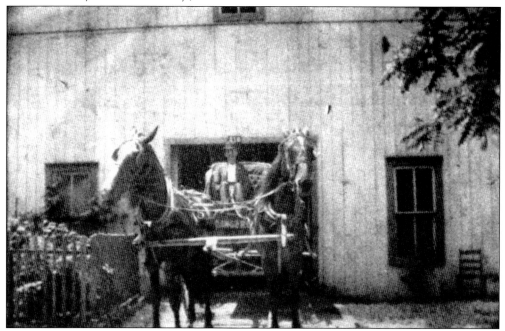

GO DEVIL. Well drillers used canisters of nitroglycerin to break through the layer of shale and release the gas. These canisters were known as "go devils." Shown here is the wagon used to deliver nitroglycerin to gas wells around Fairmount. (Courtesy Fairmount Historical Museum.)

GAS WELL ADVERTISEMENT. Businesses not directly associated with the newfound natural gas made use of its imagery in their promotional materials. Here is an advertisement for an Anderson engraver, complete with a burning gas well. (Courtesy Indiana State Library.)

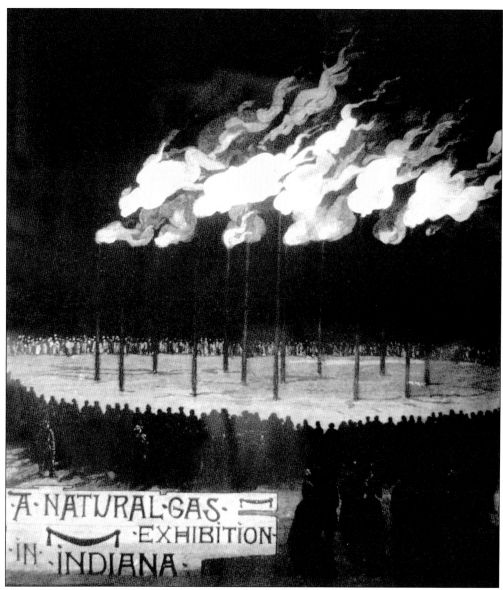

**NATURAL GAS EXPOSITION.** Simply burning gas wells was not enough. To really impress the crowds, promoters all over the Gas Belt set up massive displays of flambeaux. Flambeaux were placed along rail lines to announce the quantity of gas to the world. Downtown businesses constructed elaborate arched signs over downtown streets that would light up at night. This graphic, published in *Frank Leslie's Illustrated* on January 19, 1889, shows a brilliant circle of flambeaux.

# Two

# MUNCIE

The seat of Delaware County, Muncie was a small town of 5,500 centrally located within the Gas Belt. Eaton, site of the first well, was not far away. As a result, Muncie entered the Gas Boom early and prospered quickly. Patterns of development occurred that would be repeated in many communities of various sizes throughout the area.

A combination of the efforts of local businessmen and out-of-town speculators resulted in the rapid construction of many factories and the planning of vast new residential districts. To attract factories, industrialists were offered free land, gas, and often cash subsidies by speculators and "boomers." These industrial developments were quickly followed with new commercial districts, churches, schools, and other civic improvements required by expanding populations. By the mid-1890s, Muncie was developing at a rapid pace. The benefits of natural gas could not be disputed.

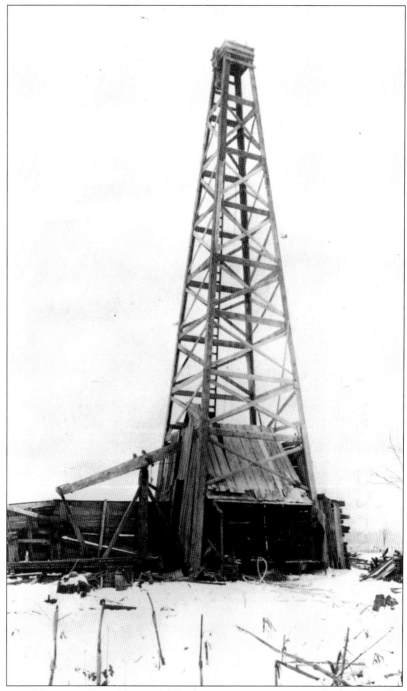

DISCOVERY OF NATURAL GAS. The established county seats were typically the first to benefit from the discovery of natural gas. Muncie was no exception. In November 1886, gas was discovered at the end of East Jackson Street. Word spread quickly, and the remainder of the decade brought prosperity that previously would have been unimaginable. By 1888, Muncie had attracted 18 factories and boasted 25 gas wells. This 1893 photograph shows a gas well on Jackson Street Pike. (Courtesy Archives and Special Collections, Bracken Library, Ball State University.)

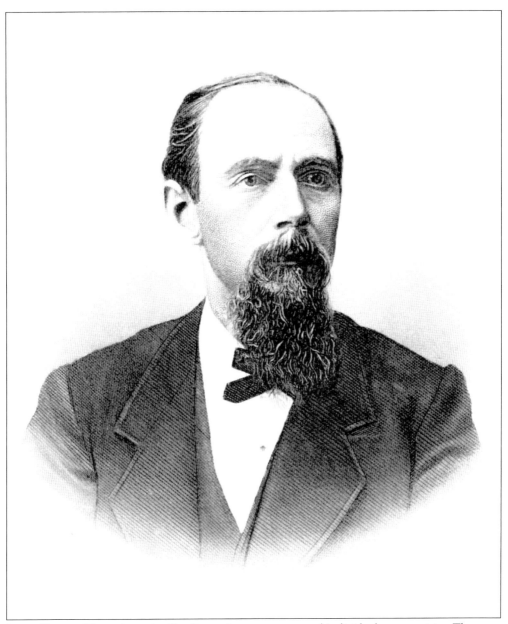

**JAMES BOYCE.** Throughout the Gas Boom, boomers promoted individual communities. The most active boomer in Muncie was James Boyce. A member of the board of trade, Boyce played a role in attracting four glass factories to Muncie in the early years of the boom. This rendering is from the 1881 *History of Delaware County, Indiana*. (Courtesy Minnetrista Heritage Collection.)

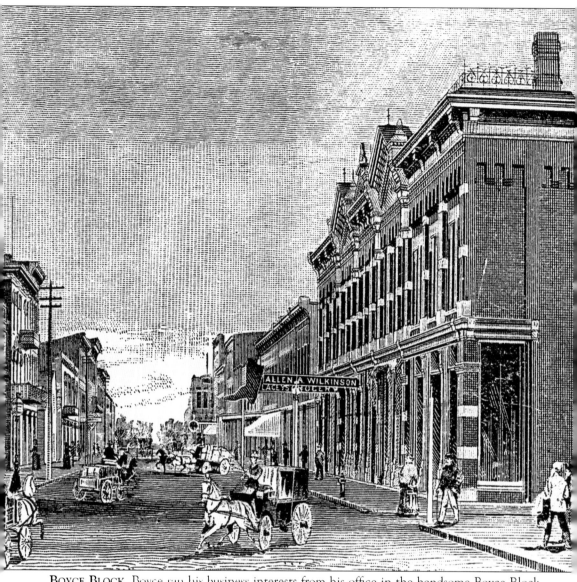

BOYCE BLOCK. Boyce ran his business interests from his office in the handsome Boyce Block, which he had constructed in downtown Muncie in 1880. Seen in this engraving of Main Street, the Boyce Block was an imposing landmark and fitting setting for the important enterprises of his office. (Courtesy Archives and Special Collections, Bracken Library, Ball State University.)

**BALL BROTHERS.** Undoubtedly, Boyce's greatest contribution to Muncie was attracting the Ball Brothers of Buffalo, New York. Boyce and the board of trade were able to lure the fruit jar manufacturer with a donation of a seven-acre site, $5,000, and a gas well. The inducement worked, and in 1887, work began on the first Ball factory. It would become the largest of Muncie's Gas Boom industries, growing to occupy 70 acres. (Courtesy Minnetrista Heritage Collection.)

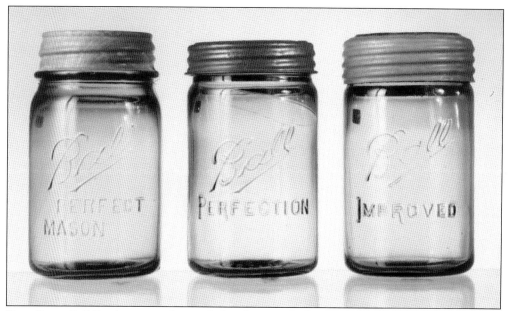

**BALL JARS.** Ball Brothers manufactured glass fruit jars for home canning. The business boomed following its relocation to Muncie. Today, the Ball mason jars are familiar all across the country. (Courtesy Minnetrista Heritage Collection.)

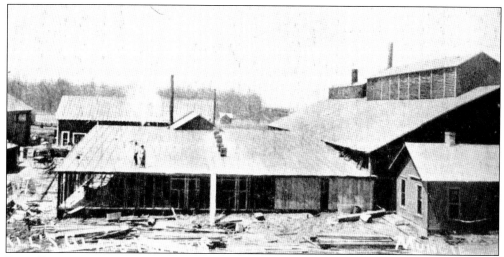

**FIRST BALL BROTHERS FACTORY.** The original Ball Brothers factory, shown here, was built in Muncie in 1887. Early Gas Boom factories were often constructed quickly and inexpensively, with the typical materials of wood and corrugated iron. If the boom went bust, the investment was small, and the factory could be easily dismantled and taken to the next boom town. However, many growing manufacturers, including Ball Brothers, soon found it necessary to build larger and more permanent brick factories. (Courtesy Minnetrista Heritage Collection.)

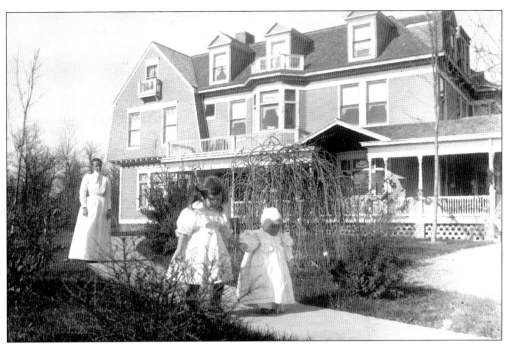

**MINNETRISTA.** When it became clear that the business in Muncie was a success, the Balls built substantial homes. Rather than settle in an established downtown neighborhood, the Balls selected a site on the White River they called Minnetrista for a campus-like setting. This collection of homes became one of Muncie's most impressive symbols of the Gas Boom. Frank C. Ball's residence, pictured in these photographs, was built in 1894, the first house on the campus. In 1902, it was grandly remodeled in the neoclassical style. (Courtesy Minnetrista Heritage Collection.)

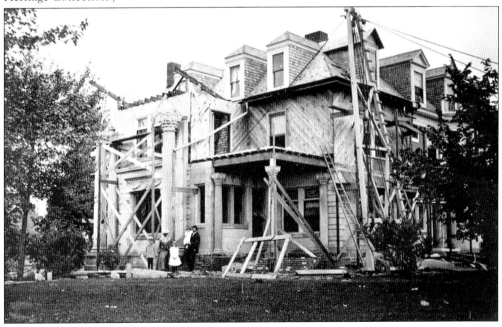

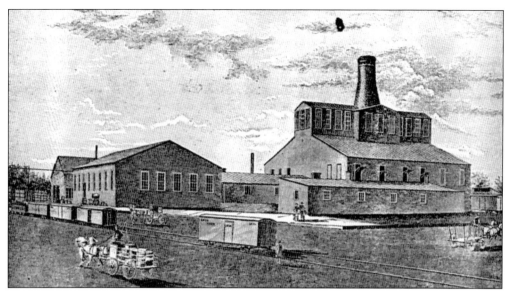

HEMINGRAY BOTTLE AND INSULATING GLASS. Another glass manufacturer attracted to Muncie was the Hemingray Bottle and Insulating Glass Company. Lured in 1888 from Covington, Kentucky, with an incentive of $7,500 and ample supplies of natural gas, Hemingray created 500 new jobs. The *Muncie Daily Times* claimed that the new factory had the potential of increasing the city's population by between 1,000 and 1,500. (Courtesy Archives and Special Collections, Bracken Library, Ball State University.)

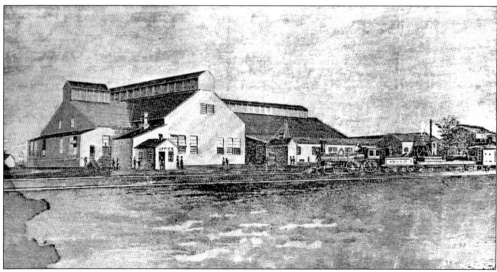

MARING, HART, AND COMPANY. This company was a window glass manufacturer lured to Muncie from Bellaire, Ohio, by James Boyce. As part of an agreement, Boyce purchased a tract of 154 acres on the east side of Muncie and laid out a factory suburb of Boyceton. Some seven acres were set aside for the factory; 26 workers' houses, a storeroom, and a school occupied the remainder of the suburb. By 1888, Boyceton had claimed over 300 residents. (Courtesy Archives and Special Collections, Bracken Library, Ball State University.)

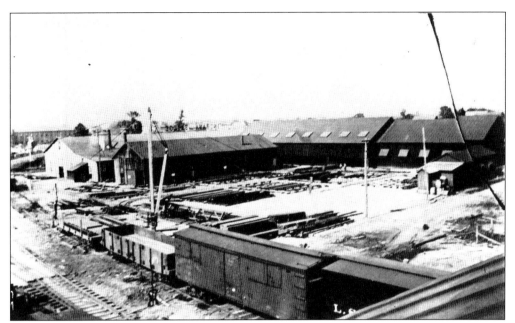

**INDIANA BRIDGE COMPANY.** Moving to Muncie from Indianapolis in 1886, the Indiana Bridge Company grew rapidly during the Gas Boom. The firm manufactured iron and steel bridges, which were installed all over Indiana and the Midwest. The above photograph shows the factory buildings in July 1890. Below is the construction of the template shop in May of that year. (Courtesy Archives and Special Collections, Bracken Library, Ball State University.)

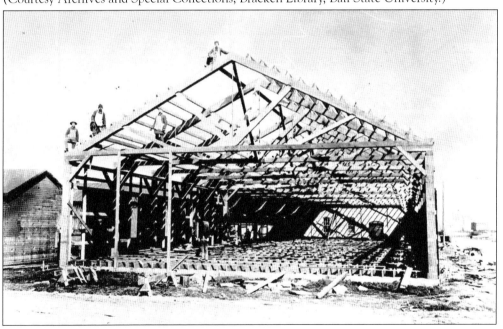

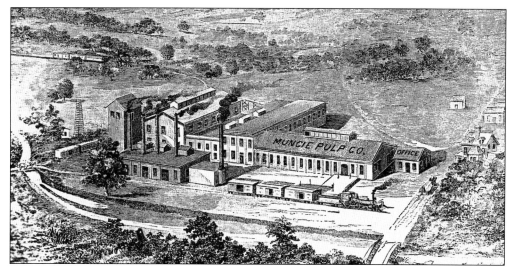

**MUNCIE PULP COMPANY.** Paper companies such as the Muncie Pulp Company were also attracted by the promise of free natural gas. (Courtesy Archives and Special Collections, Bracken Library, Ball State University.)

**C. H. OVER AND COMPANY GLASS WORKS.** Yet another glass factory that located in Muncie during the late 1880s, C. H. Over and Company employed 175 workers. (Courtesy Archives and Special Collections, Bracken Library, Ball State University.)

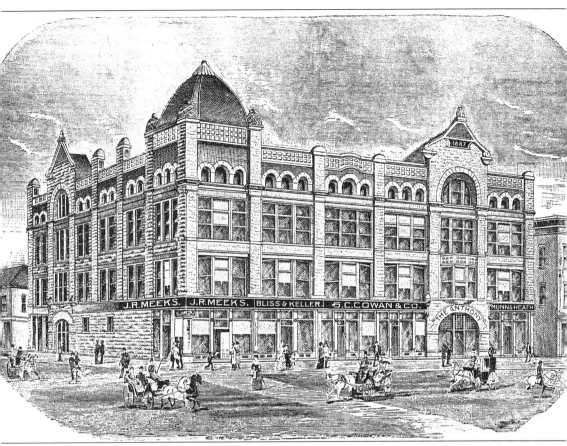

**ANTHONY BLOCK.** Another prominent businessman of the Gas Boom, Charles H. Anthony served as president and organizer of Muncie's first gas firm: the Enterprise Gas Company. He was also active in the formation of the Citizens' Enterprise Company, established to lure manufacturers to town. His family had long been active in real estate, and Anthony would use this to his and Muncie's advantage. He was quick to realize the economic prosperity that natural gas would bring. In 1887, he built the Anthony Block at the corner of Jackson and Walnut Streets. The imposing stone building was built in the Romanesque style, popular during the boom era. The building soon became home to two real-estate syndicates: the Delaware County Land Improvement Company and the Muncie Natural Gas Land Company. (Courtesy Archives and Special Collections, Bracken Library, Ball State University.)

# MUNCIE, INDIANA:

## THE NATURAL GAS CITY OF THE WEST.

ITS HISTORY, PAST AND PRESENT.

### Advantages for Manufacturers, Capitalists and Investors.

A BRIEF DESCRIPTION OF WHAT HAS BEEN ACCOMPLISHED AND ITS BRIGHT PROSPECTS.

Published by the
MUNCIE NATURAL GAS LAND IMPROVEMENT COMPANY,
MUNCIE, INDIANA

LAND SYNDICATES. Muncie's boom attracted the attention of a syndicate of investors from Ohio, New Jersey, and New York. Organizing the Muncie Natural Gas Land Company and recruiting former New Jersey governor Leon Abbett as president, these investors purchased large tracts of land south of the city. They hoped to lure industry with the promise of free land and gas, publishing a lavish prospectus in 1889. A competing syndicate from Indiana and Michigan formed the Delaware County Land Improvement Company and made the same offer with land west of town. However, most development would take place closer to the center of town. (Courtesy Archives and Special Collections, Bracken Library, Ball State University.)

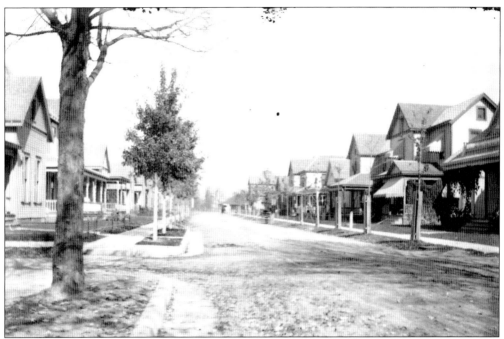

MUNCIE GROWS. Within four years of the discovery of natural gas, Muncie's population more than doubled from 5,500 to 11,345. Boyceton was only one example of a residential development. Simple one-story homes were quickly erected for workers, while more substantial homes in the Queen Anne style housed the wealthy. Queen Annes displayed the status of their owners with complex rooflines, fancy woodwork, and ample porches. These views of Vine Street, taken at the dawn of the 20th century, illustrate a typical residential street in boom-era Muncie. (Courtesy Minnetrista Heritage Collection.)

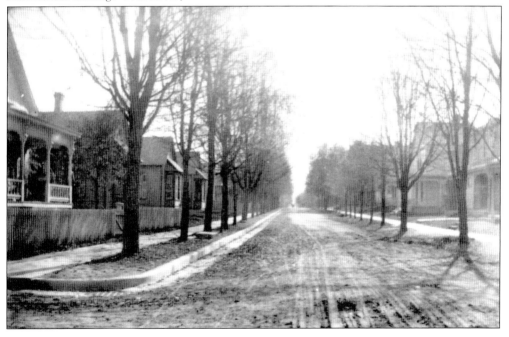

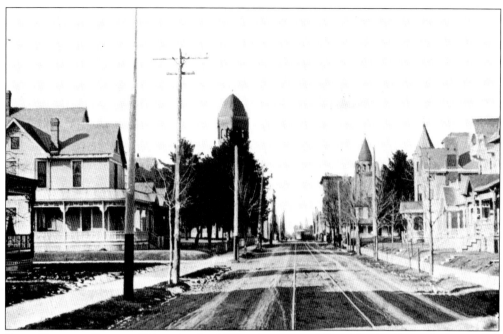

EAST CHARLES STREET. Taken in the 1890s, this view of East Charles Street looks toward downtown. Both sides of the street are lined with handsome Queen Anne homes, while the towers of two Gas Boom–era churches—First Baptist and First Presbyterian—rise in the distance. (Courtesy Archives and Special Collections, Bracken Library, Ball State University.)

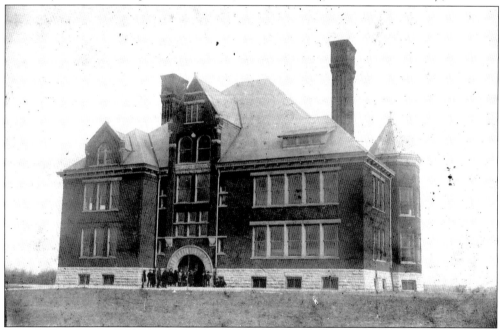

BLAINE SCHOOL. In addition to homes, the new residential districts required schools. This photograph shows the Blaine School in May 1894. This was one of many brick Romanesque schools built throughout the Gas Belt. The distinctive elements are the towers, arched windows, and arched entrance. (Courtesy Minnetrista Heritage Collection.)

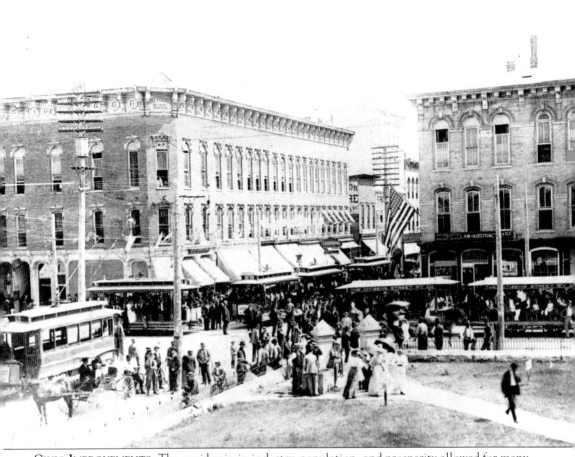

CIVIC IMPROVEMENTS. The rapid gain in industry, population, and prosperity allowed for many improvements. Quality of life in Muncie was raised with improving infrastructure and services. As early as the spring of 1887, the Muncie Natural Gas Company was laying gas mains throughout the city, offering inexpensive heat. Citizens also soon enjoyed the latest in transportation. This photograph, taken from the courthouse, shows the opening of the new electric streetcar lines in 1893. The event has drawn a crowd and inspired business owners to fly flags from the windows of their blocks. (Courtesy Minnetrista Heritage Collection.)

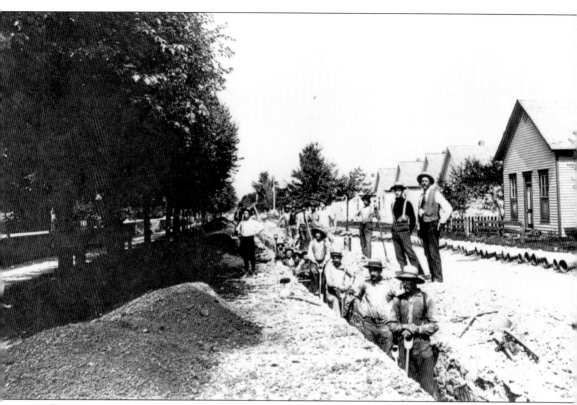

BUILDING A SEWER LINE. Another civic improvement is shown in this July 2, 1896, image. A sewer line is being constructed along East Adams Street, near the intersection with Ohio. A row of workers' cottages is visible in the background. (Courtesy Archives and Special Collections, Bracken Library, Ball State University.)

# Three

# ANDERSON

The county seat of Madison County, Anderson had been a small community since its founding in 1829. The town mainly depended upon the surrounding agriculture and modest industry. With the discovery of natural gas, however, Anderson would quickly rival Muncie for its share of industry and development.

The first natural gas well in Madison County was discovered on February 28, 1887, in Alexandria. Citizens of Anderson took note, and 40 of the town's businessmen contributed $20,000 to launch the Anderson Natural Gas and Oil Company. The firm drilled directly south of the Midland railway station on land donated by John Hickey. The investment proved its worth on March 31, when natural gas was struck. As the gas was lit, flames soared over 100 feet. The Gas Boom had arrived in Anderson.

Anderson's chief "boomers" were Maj. Charles T. Doxey and Neal McCullough. Doxey owned considerable real estate and built gas pipelines to supply Richmond. McCullough discovered a massive gas well on the east bank of the White River and dubbed it "Vesuvius." Excursion trains brought curiosity seekers to admire the big well gushing lighted gas. Vesuvius was a testament to the abundance of Anderson's natural gas. The promotions paid off in late 1887, when Anderson landed its first factory. Induced by free land and gas, the Fowler Nuts and Bolts Company moved to the town from Buffalo, New York.

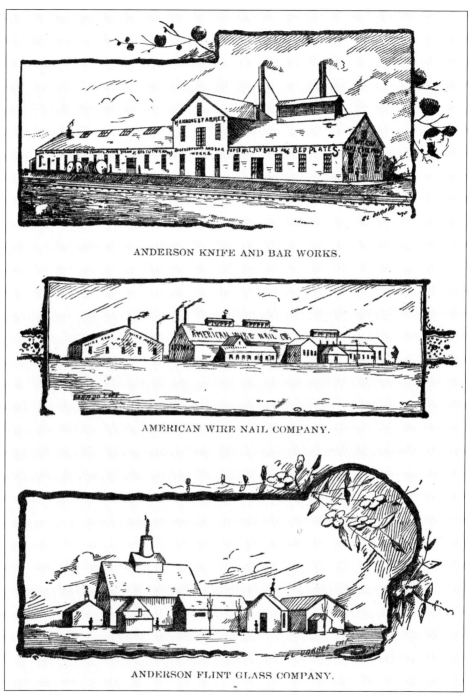

ANDERSON KNIFE AND BAR WORKS.

AMERICAN WIRE NAIL COMPANY.

ANDERSON FLINT GLASS COMPANY.

**FACTORIES RELOCATE TO ANDERSON.** Several other factories followed Fowler in rapid succession. They produced a wide variety of items, ranging from butter dishes to knives. The prospect of cheap or free natural gas was an attraction too good to pass up. This rendering shows three of the factories brought to Anderson between 1888 and 1889: the Anderson Knife and Bar Works, American Wire Nail Company, and Anderson Flint Glass Company. (Courtesy Indiana State Library.)

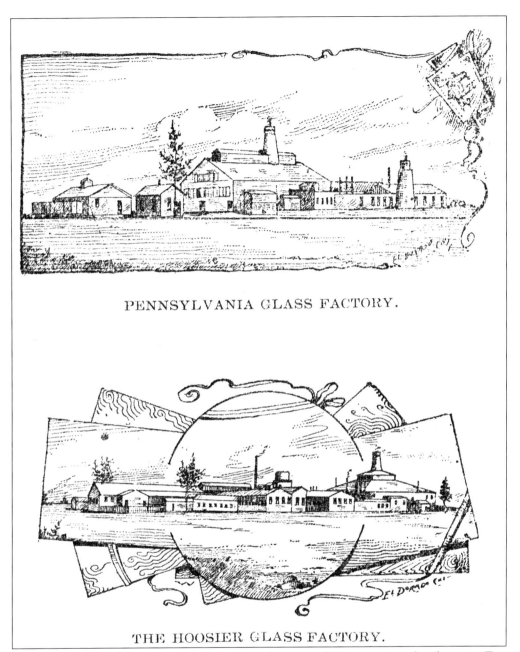

ANDERSON'S GLASS FACTORIES. Anderson was also successful in attracting glass factories. Two such establishments were the Pennsylvania Glass Company and the Hoosier Glass Company, seen here in 1891. (Courtesy Indiana State Library.)

ANDERSON STRAWBOARD WORKS. Shown here, the Anderson Strawboard Works was another substantial factory lured to the town with offers of free gas. (Courtesy Indiana State Library.)

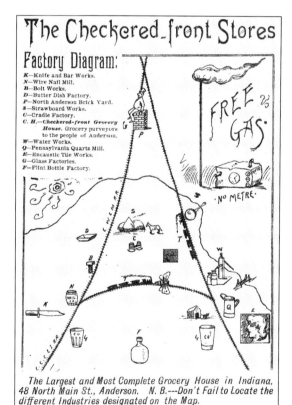

MAP OF ANDERSON'S FACTORIES. By 1891, a wide variety of manufacturers had established themselves in Anderson. This advertisement for the Checkered-Front Stores illustrates the distribution of the factories across the city and the grocery store's central location. It also features a prominent flambeau and a promise of unlimited free gas. (Courtesy Indiana State Library.)

SHADELAND'S ADDITION. Like Muncie, Anderson expanded with a number of suburbs. One of these was former Indiana lieutenant governor William Cumback's Shadeland Addition. Cumback, seen below, platted 113 lots for a high-grade residential section located near the factories of American Wire and Nail, Knife and Bar Works, Anderson Paper Mill, Anderson Flint Bottle Works, and Cathedral Glass Works. The advertisement at right highlights the availability of a gas well for residents at low rates. Within 90 days on the market, 75 Shadeland lots had been sold and 25 houses were under construction. (Courtesy Indiana State Library.)

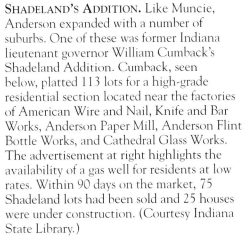

CUMBACK'S
"SHADELAND"
ADDITION.
MOST BEAUTIFUL ADDITION TO THE
CITY OF ANDERSON,
Lots sold on Easy Terms to purchasers
A BIG GAS WELL
FOR USE OF RESIDENTS ON THE ADDITION.
RATES FOR GAS VERY CHEAP.
LOTS BEING TAKEN EVERY DAY
Office: First Floor Anderson Banking Company Building, near Post Office, ANDERSON, INDIANA.

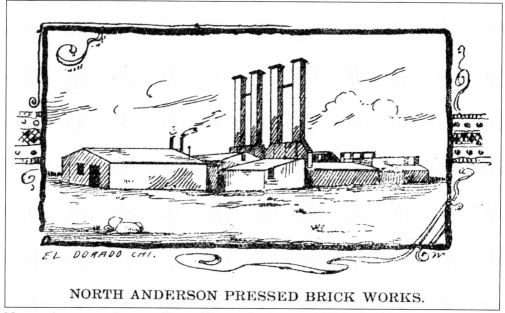

**NORTH ANDERSON PRESSED BRICK WORKS.** Laid out in 1890 by local businessman Charles Henry and Marion investor Philip Matter, North Anderson was located one mile north of the town limits. The suburb did well for itself, attracting four factories in the early 1890s. One of these was the North Anderson Pressed Brick Works. Seen in this period rendering, the brick works was dominated by four massive stacks. (Courtesy Indiana State Library.)

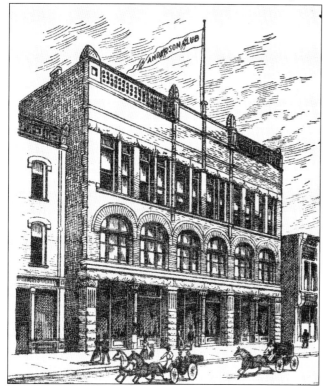

**POST OFFICE BLOCK.** As with Muncie, many fine business blocks were constructed in downtown Anderson in the prevalent style of Romanesque. The Post Office Block, built by Durbin and McCullough, is a typical example. The building served as home to the Anderson Club. (Courtesy Indiana State Library.)

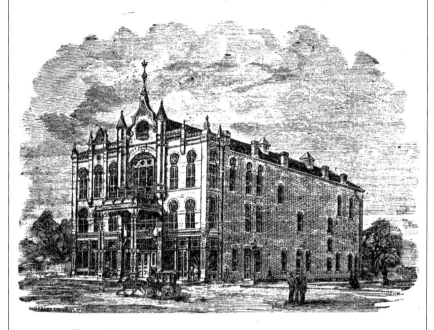

Doxey's Opera House. Downtown Anderson's most ornate Gas Boom building was the opera house built by Maj. Charles Doxey. One of two theaters in 1891, the 1,000-seat auditorium brought cultural distinction to the growing city. This advertisement boasts the opera house's amenities. (Courtesy Indiana State Library.)

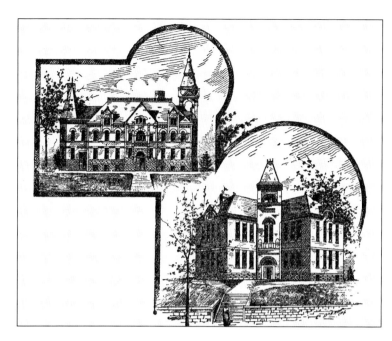

SCHOOLS. Anderson's population grew rapidly. In 1887, the city was at 7,000; four years later, it was at over 15,000. New schools such as these were built across the city. They reflect trends of the popular Romanesque style visible in many Gas Boom–era structures. (Courtesy Indiana State Library.)

QUEEN ANNES. Like Muncie, Anderson witnessed a building boom of residences for both upper and working classes. Judge M. A. Chipman's house, seen here, was a fine example of the Queen Anne style, which was popular for residences among the upper classes. (Courtesy Indiana State Library.)

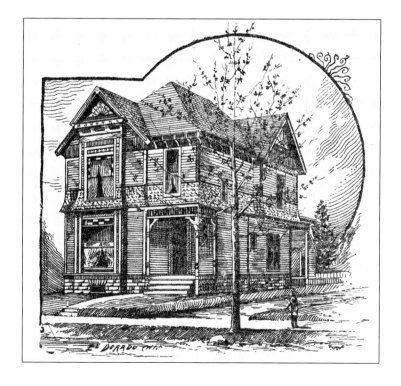

# *Four*
# Kokomo

Kokomo, the seat of Howard County, also followed the pattern of discovery and boom occurring in both Muncie and Anderson. After gas was discovered in 1886, the city was able to attract a large plate-glass manufacturer as well as a number of paper mills and other industries within a very short time. Kokomo experienced a pattern of real-estate speculation not unlike the other county seats. In the spring of 1887, outside investors formed real-estate syndicates to buy up property in and around the city. Locals organized similar endeavors to compete. Area businessmen formed the Kokomo Improvement Company to offer incentives for industrialists to locate plants in Kokomo. This company offered a nearly free supply of gas, cash subsidies, and assistance in acquiring land. The Kokomo Window Glass Company was the first factory acquired by these efforts

    The city's rapid development resulted in a building boom of civic infrastructure, best seen in the elaborate new city hall. Factory managers and other citizens built fine new homes, while newly platted workers' neighborhoods filled in the land around the factories. By the mid-1890s, Kokomo had easily established itself as the chief industrial city of the Gas Belt's northwest section.

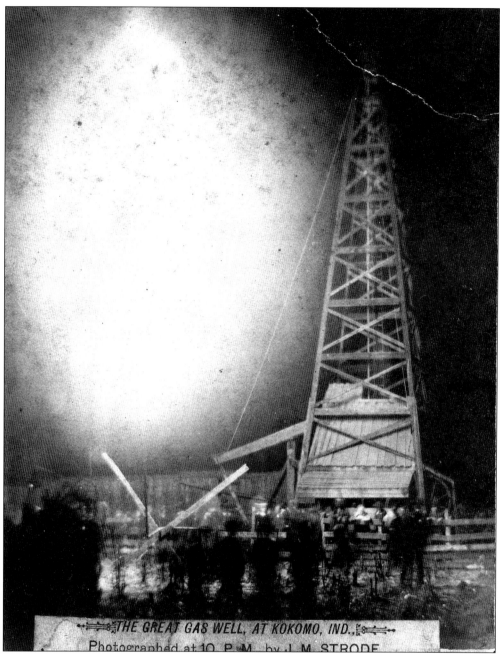

DISCOVERY OF NATURAL GAS. In the spring of 1886, two young businessmen—A. Y. Comstock and D. C. Spraker—organized a subscription drive among local citizens to raise capital to drill for gas. On October 6, they struck gas in a cornfield just south of Wild Cat Creek. When additional wells were discovered nearby, the boom arrived in Kokomo. Here, the gas well of Fred Shrader is lit up at night in an impressive flambeau. (Courtesy Howard County Historical Society.)

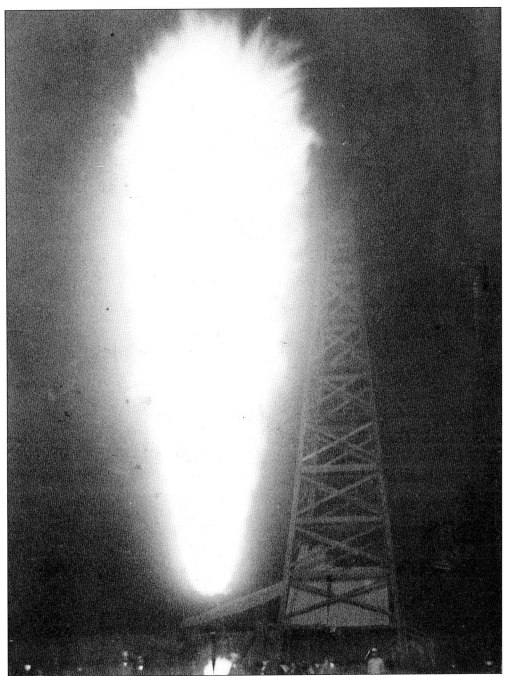

**SHRADER'S GAS WELL AT KOKOMO.** Located near the intersection of Hoffer and Plate Streets, the Shrader well produced a flame over 70 feet high and a flow of 12 cubic feet per day. Excursion trains were organized from Chicago to bring sightseers to witness Kokomo's abundant gas supply. (Courtesy Howard County Historical Society.)

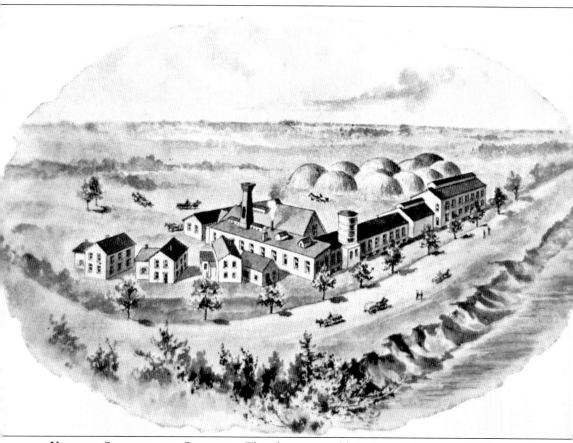

KOKOMO STRAWBOARD COMPANY. This factory, established in Kokomo in 1887, was the collaboration of two businessmen: Monroe Seiberling and a partner named Williams. The Kokomo Improvement Company provided the investors with $2,000, which they used to purchase 10 acres of land on the southeast side of the city. (Courtesy Indiana State Library.)

KOKOMO PAPER COMPANY. Another manufacturer attracted by the Kokomo Improvement Company was the Kokomo Paper Company, which located near the strawboard factory. (Courtesy Indiana State Library.)

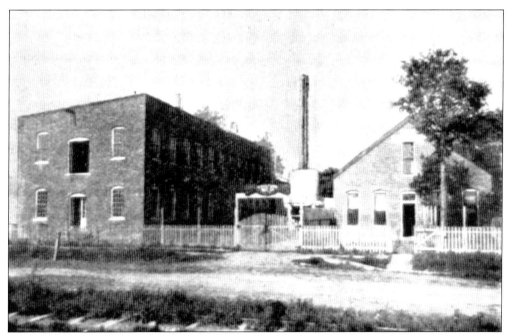

ROCKFORD BIT COMPANY. In 1888, the owner of the Rockford Bit Company solicited city leaders for a site to locate his factory. A local speculator donated six acres south of the city limits, and soon this building employed 75 men and produced two million bits and augers a year. (Courtesy Indiana State Library.)

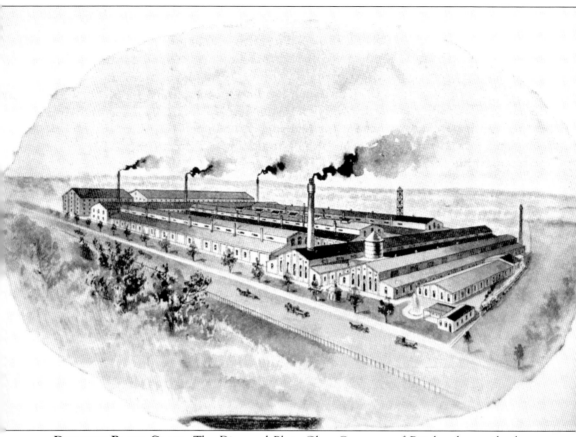

DIAMOND PLATE GLASS. The Diamond Plate Glass Company of Pittsburgh was the largest Gas Boom factory in Kokomo. Its president, A. L. Conger, was an investor in a number of Indiana Gas Belt communities. He personally served as an officer in real-estate concerns and local businesses in Elwood and Hartford City. In Muncie, he was persuaded by the Citizens Enterprise Company in the mid-1890s to develop Congerville south of Eighteenth Street as a residential neighborhood for workers. His Diamond Plate Glass plant was built southeast of the center of Kokomo, covering approximately 13 acres and employing 750 men by 1893. (Courtesy Indiana State Library.)

MONROE SEIBERLING. Conger employed the services of Monroe Seiberling and his brother James to manage Diamond Plate Glass. The Seiberlings became prominent figures in Kokomo and active in other areas of the Gas Belt. They later erected a second Diamond Plate Glass factory in Elwood and partnered with John E. Miller to create the town of Gas City. (Courtesy Howard County Historical Society.)

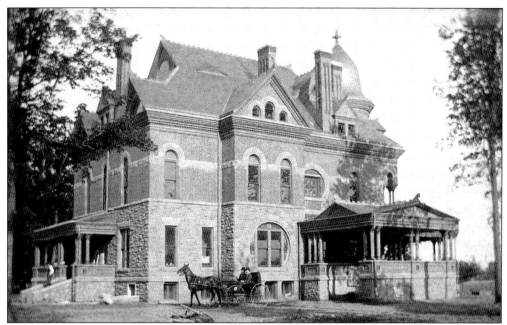

SEIBERLING HOUSE. In 1891, Monroe Seiberling built this elaborate Romanesque home on West Sycamore Street. The brown stone and pressed brick structure cost $50,000, with an additional stable costing $6,000. The Seiberling family resided here until 1895, when Diamond Plate Glass became part of the Pittsburgh Plate Glass Company. Monroe Seiberling then moved to Peoria, Illinois, organizing the Peoria Rubber and Manufacturing Company. (Courtesy Howard County Historical Society.)

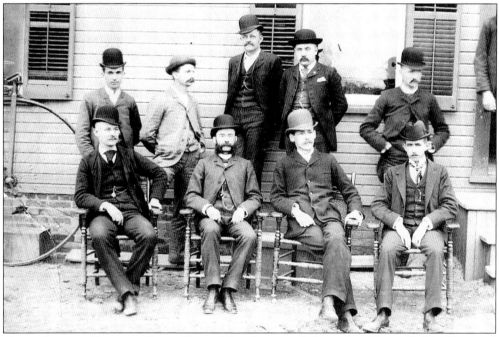

OFFICE STAFF OF DIAMOND PLATE GLASS. This photograph shows the office staff of the Diamond Plate Glass Company in the mid-1890s. (Courtesy Howard County Historical Society.)

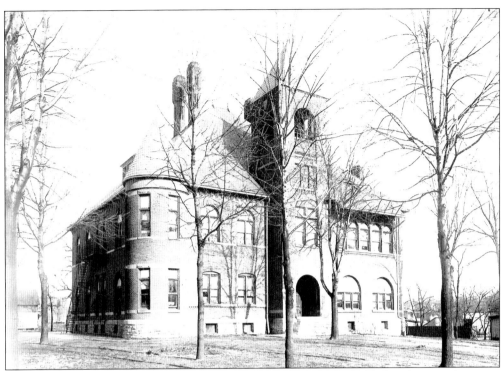

**THE LINCOLN SCHOOL.** Increased population and wealth both enabled and required a series of civic improvements. As was happening elsewhere around the Gas Belt, a number of brick Romanesque schools were built to house the growing student population. The Lincoln School, pictured here, was constructed in 1887. (Courtesy Howard County Historical Society.)

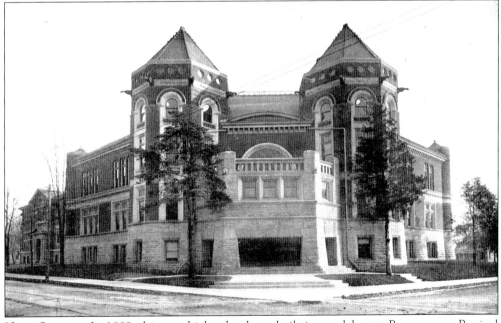

**HIGH SCHOOL.** In 1898, this new high school was built in an elaborate Romanesque Revival style. (Courtesy Howard County Historical Society.)

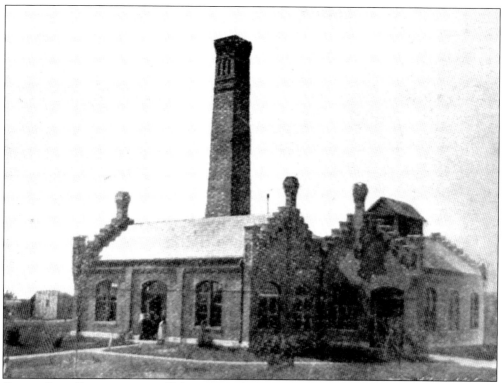

OTHER CIVIC IMPROVEMENTS. Kokomo's residents enjoyed the benefit of modern progress. The city had an ample sewage system, electricity, street railways, and waterworks. The photograph above shows the substantial brick waterworks plant, while the photograph below depicts the electric light plant and street railway station. (Courtesy Indiana State Library.)

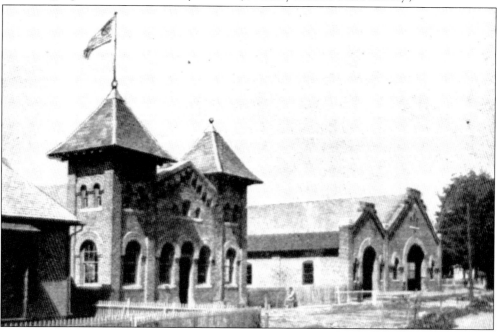

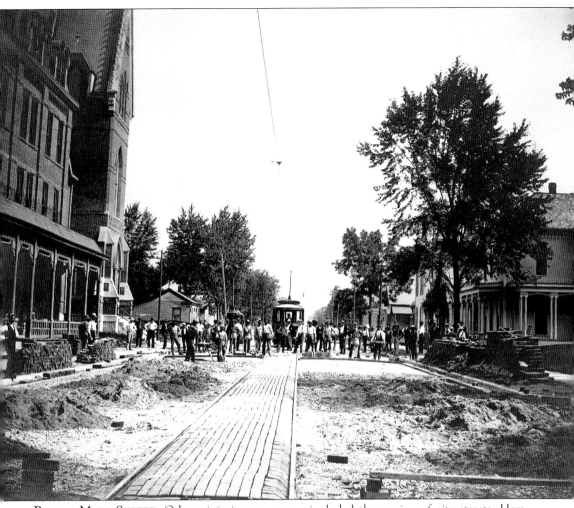

PAVING MAIN STREET. Other civic improvements included the paving of city streets. Here, paving occurs on Main Street between Taylor and Jackson. The Courtland Hotel and Main Street Christian Church are visible in the background. (Courtesy Howard County Historical Society.)

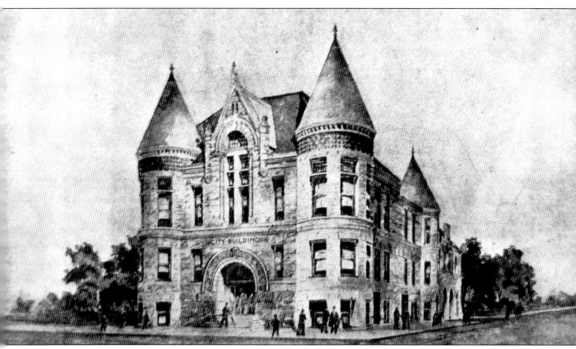

**CITY HALL.** Kokomo's grandest civic improvement during the Gas Boom was the construction of a new city hall in 1893. The stone building, designed by Fort Wayne architects Wing and Mahurin, resembled a French chateau and housed all municipal departments. (Courtesy Indiana State Library.)

# Five

# MARION

Marion, the seat of Grant County, was located in the northern section of the Gas Belt. Prior to the discovery of natural gas in 1887, Marion was much like Muncie, Anderson, and Kokomo: a small town surrounded by agriculture. However, over a five-year period, Marion would become the site of the most flamboyant promotions of the Gas Belt and the location of choice for dozens of factories. Promoter George L. Mason overshadowed all others with his national advertising campaign and real-estate developments designed to make Marion the "Queen City" of the Gas Belt. Many factories did establish themselves in Marion, enabling the city to grow and prosper. Marion's gas wealth also attracted the federal government to build the National Home for Disabled Volunteer Soldiers. By the early 1890s, Marion's future seemed guaranteed.

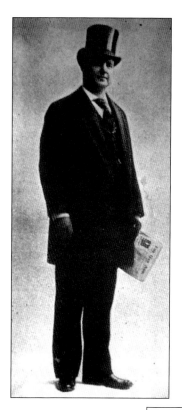

**GEORGE L. MASON.** Marion was the adopted city of the Gas Boom's most extravagant boomer: George L. Mason. Mason arrived in Marion within two years of the discovery of natural gas and billed himself as the guiding force behind the booming of Birmingham, Alabama, a major steel city of the 1880s. In this *Frank Leslie's Illustrated* image of July 4, 1891, Mason holds his monthly newspaper, the *Gas Age*, which he claimed had a circulation of 100,000.

**CENTER OF THE GAS BELT.** This map, reproduced from the *Frank Leslie's Illustrated* of July 4, 1891, shows Marion's appeal to industrialists. The city is at the center of the Gas Belt, close to all of the largest markets for industry in the Midwest and close to coal and oil—the ideal place for the industrialists to invest.

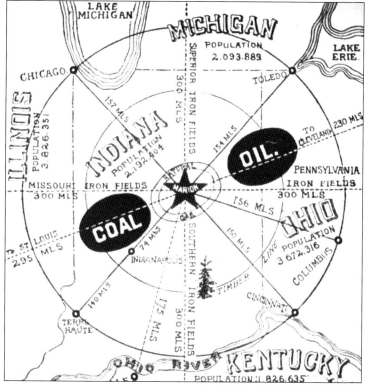

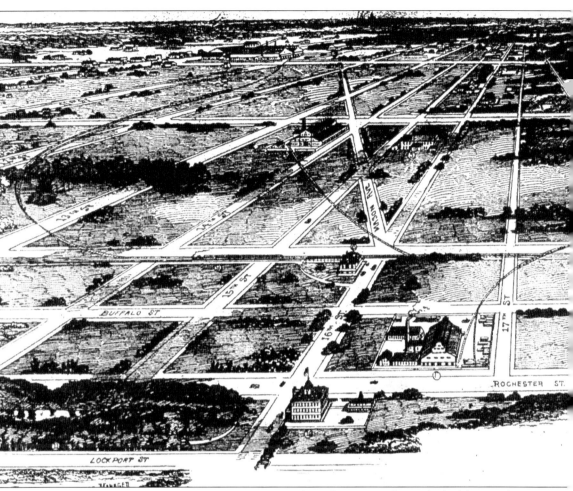

**MASON'S REAL-ESTATE ADDITIONS.** Partnering with William H. Wiley and Thaddeus Butler, Mason bought 500 acres west of the city limits and laid out several real-estate additions. The gridiron plats featured street names from cities in Mason's home state of New York and a long, diagonal Mason Avenue. This image was first printed in *Frank Leslie's Illustrated* on November 22, 1890.

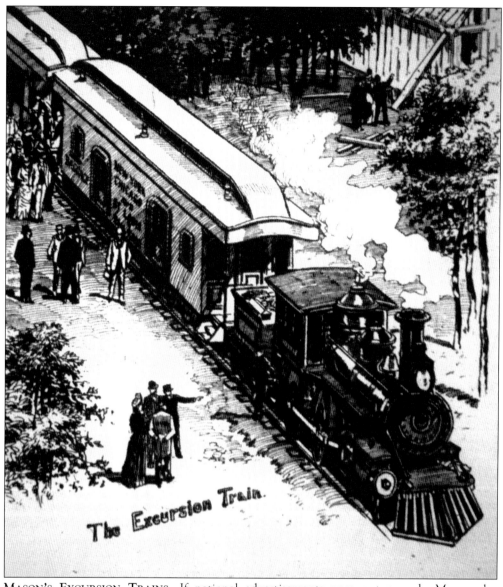

MASON'S EXCURSION TRAINS. If national advertisements were not enough, Mason also organized excursion trains from Buffalo so that industrialists could see the marvels of Marion firsthand. The trains are seen in this image from the *Frank Leslie's Illustrated* of July 4, 1891.

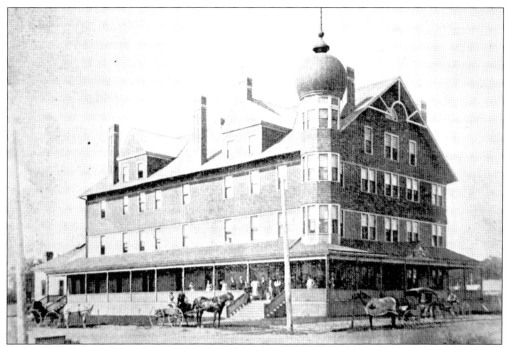

**YORK INN.** Once in Marion, industrialists were housed at the York Inn, an elaborate Shingle-style edifice built expressly for this purpose. The York Inn was an impressive sight. Equally grand was Mason's hospitality for potential industrialists. (Courtesy Indiana State Library.)

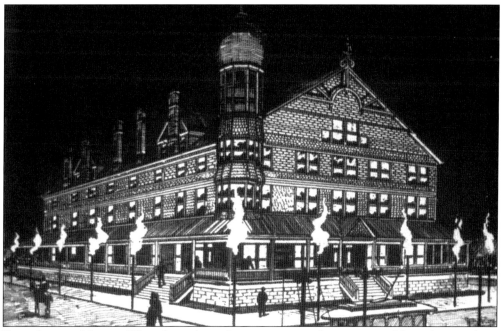

**YORK INN AT NIGHT.** What the industrialists came to see, however, was Marion's natural gas wealth. To remind them of the city's abundance of fuel, Mason had flambeaux placed around the entire perimeter of the hotel, shown in an image from the *Frank Leslie's Illustrated* of July 4, 1891.

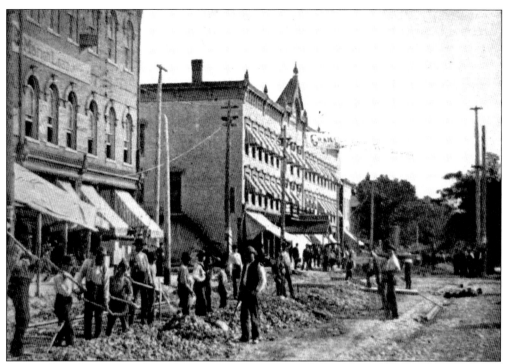

QUEEN CITY STREETCAR LINE. Transportation was provided to Mason's developments via the Queen City streetcar line, built by Mason. In these images, track is laid and trolley wire is strung for that line. (Courtesy Indiana State Library.)

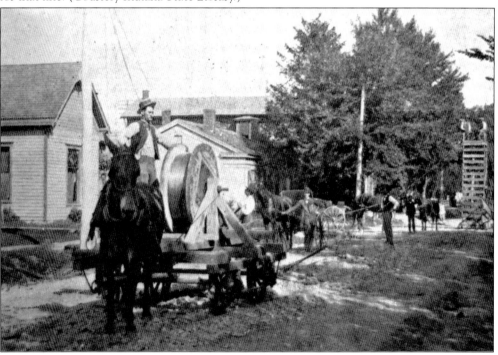

**MASON'S SUBURBS.** Visiting industrialists were sure to see the fine residential developments rising in Mason's additions. This *Frank Leslie's Illustrated* image from July 4, 1891, shows some of Mason's new homes for managers.

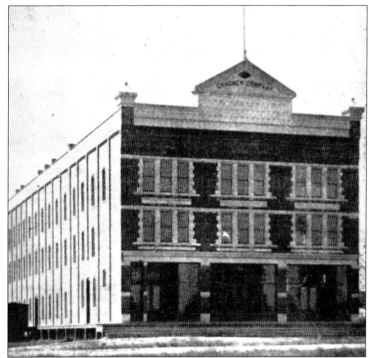

**DIAMOND CRACKER FACTORY.** An early business to locate in Mason's addition was the Diamond Cracker factory. The company built one of the Gas Boom's most substantial factories at a site near the York Inn. However, Diamond Cracker went out of business before ever producing a single cracker. The building was acquired by a bed manufacturer. (Courtesy Indiana State Library.)

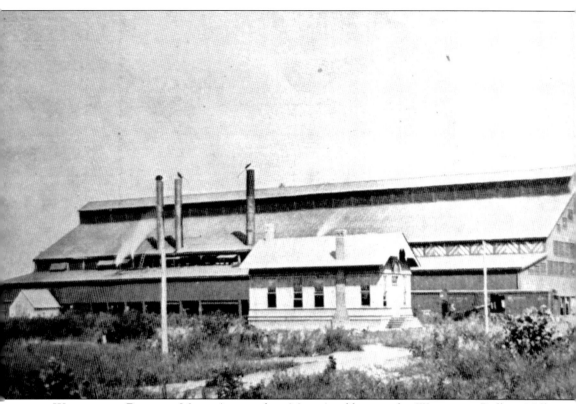

WESTERMAN ROLLING MILL. Attracted to Mason's additions, the Westerman Rolling Mill arrived in Marion, building an imposing complex in 1891 to create sheet metal. The Queen City streetcar line traveled directly to Westerman's doorstep. (Courtesy Indiana State Library.)

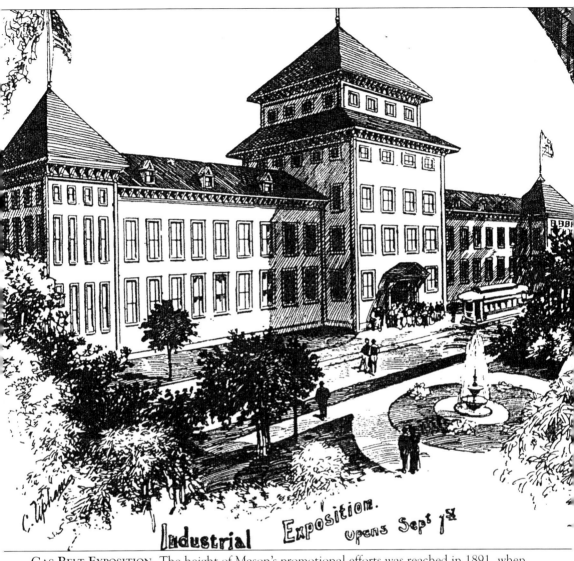

**GAS BELT EXPOSITION.** The height of Mason's promotional efforts was reached in 1891, when he advertised that he would hold the Gas Belt Exposition in his additions for the whole nation. This rendering, published on July 4, 1891, in *Frank Leslie's Illustrated*, shows the pavilion to be built for the event.

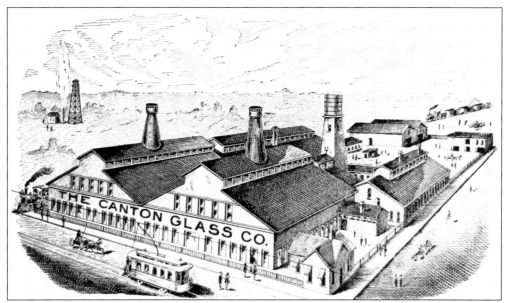

CANTON GLASS WORKS. Mason and his partners were not the only boomers active in Marion. The Marion Real Estate Company laid out the Marion Real Estate Tract on land one and a half miles northwest of the courthouse. Within a few years, it had attracted 11 factories. One of the largest was the Canton Glass Works, in 1890. Originally from Canton, Ohio, the factory manufactured a variety of goods, including bar ware, drug sundries, tableware, and glass novelties. The factory is seen here, with a gas well in the background. (Courtesy Indiana State Library.)

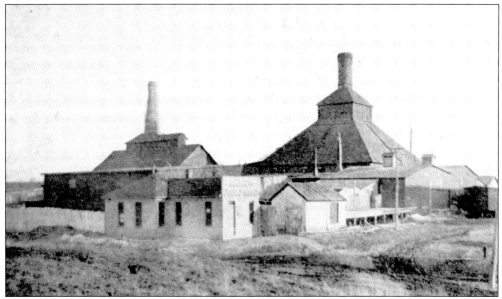

MARION FLINT GLASS. Two experienced boomers from Findlay, Ohio—Gray and Dodds—purchased land north of the Mississenewa River and formed the suburb of North Marion in 1887. Within two years, a number of factories had set up shop, including Marion Window Glass, the Western Glass Company, Marion Handle Works, the Marion Paper Company, and the pictured Marion Flint Glass Company. (Courtesy Indiana State Library.)

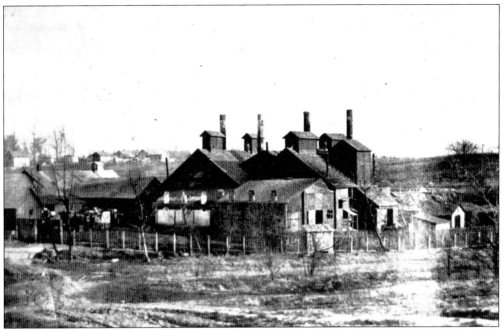

**WESTERN GLASS WORKS.** Marion's reputation as a factory mecca was enough to attract the Western Glass Works in 1890. The company never requested cash, gas, or land in order to relocate to Gray and Dodds's North Marion suburb. This unsubsidized development, however, was the exception rather than the rule. (Courtesy Indiana State Library.)

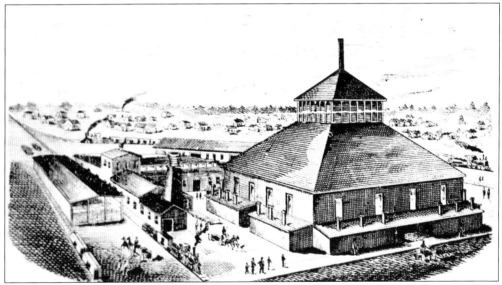

**MARION FRUIT JAR.** Approximately three miles south of the town center, real-estate investors Winchel and Webster laid out the factory suburb of South Marion in 1888. This separate town, connected to Marion by a streetcar line, contained its own business district, residential plat for workers' cottages, and factory sites. Among the factories attracted to the suburb was the Marion Fruit Jar and Bottle Works in 1888. Manufacturing fruit jars, bottles, and oil cans, this company, run by J. L. McCullough and J. Wood Wilson, was a rival to Ball Brothers of Muncie. (Courtesy Indiana State Library.)

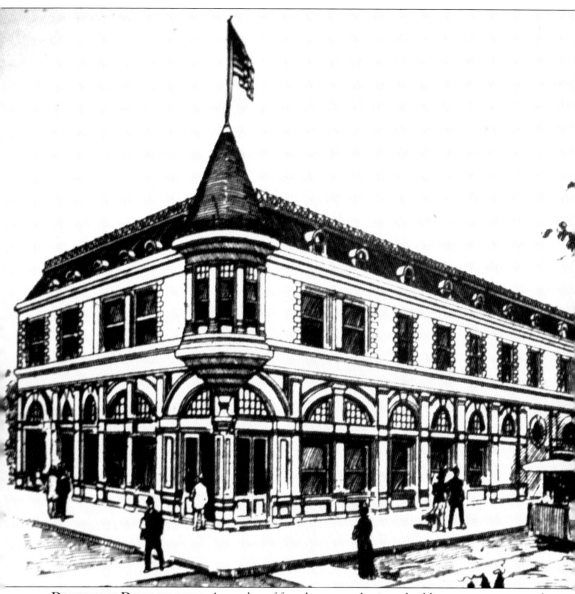

**Downtown Developments.** A number of fine downtown business buildings were constructed for the city's growing needs. The Mason, Wiley, Butler Block, shown in an image from the *Frank Leslie's Illustrated* of July 4, 1891, was home to George Mason's business interests and the setting for the development of his extravagant plans.

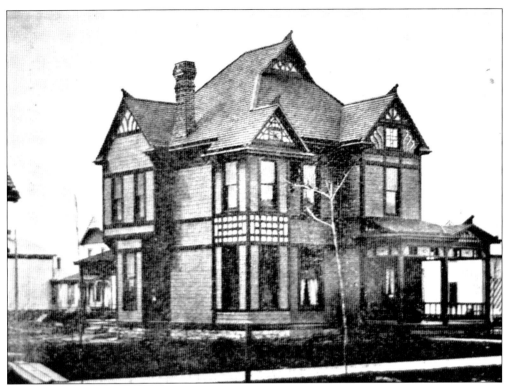

QUEEN ANNE RESIDENCES. Marion's prosperous citizens were as in tune with national taste as those in other communities. These two residences are examples of the fine Queen Annes that were built around downtown Marion in the 1890s. (Courtesy Indiana State Library.)

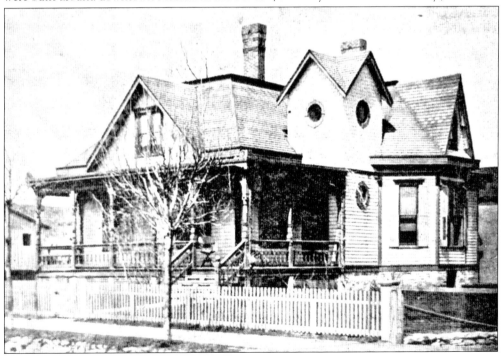

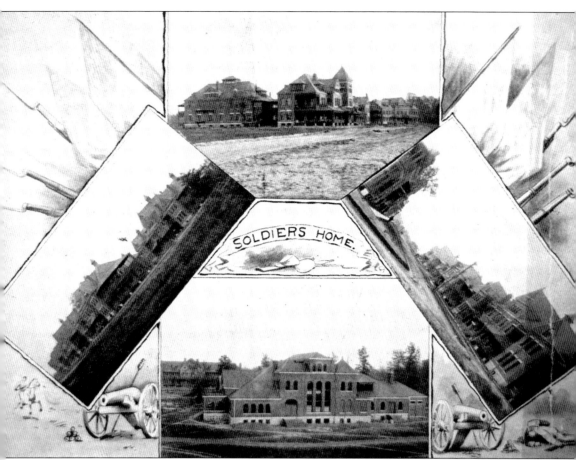

**HOME FOR DISABLED VOLUNTEER SOLDIERS.** One of the greatest and long-lasting boosts to Marion was the construction of the National Home for Disabled Volunteer Soldiers southeast of town. Primarily servicing Civil War veterans, the home was obtained for Marion through the influence of Indiana congressman George W. Steele. Steele argued successfully that the cheap natural gas available in Marion would make the operating costs much lower than elsewhere. This view shows several of the home's structures. By 1900, the complex included over a dozen buildings and housed some 2,000 veterans. (Courtesy Indiana State Library.)

# Six

# THE SMALLER COMMUNITIES

The smaller villages and country towns of the Gas Belt were overshadowed by the county seats during the first three to four years of the Gas Boom. By the early 1890s, though, both Gas Belt businessmen and outside investors began to shift attention to developing the many small communities in east-central Indiana. Often the impetus for promotion and speculation came from the same investors who had previously participated in the development of the county seats. As a result, the Gas Boom development in these smaller communities closely matched the events that had occurred in the county seats.

Promoters practiced real-estate speculation, buying up land around communities and platting out new subdivisions in hopes of striking it big when factories moved into town. Industrialists were offered land, cash subsidies, and gas wells to construct plants around these subdivisions. As factories attracted workers, populations increased dramatically, creating towns out of small hamlets and villages. The communities of Elwood, Fairmount, and Gas City serve as apt illustrations of the Gas Boom influence on village life.

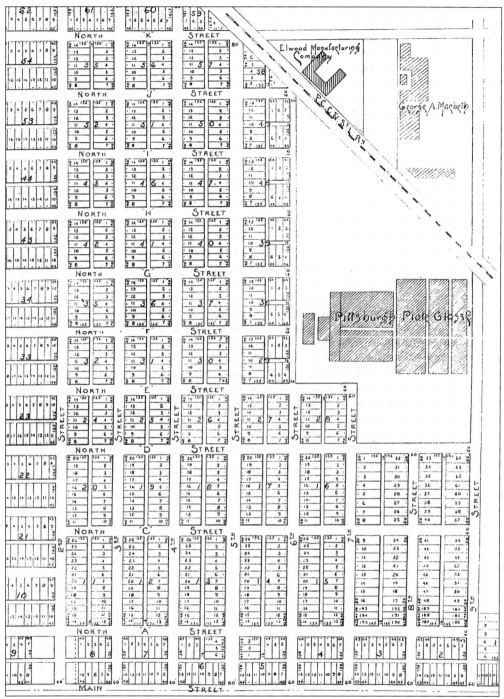

**PLAT OF NORTHWEST ELWOOD.** Elwood had been a small town in northern Madison County before the Gas Boom. However, in the early 1890s, outside investors joined with local families such as the DeHoritys and Callaways in building factories around the outskirts of town and platting adjacent real-estate additions. Elwood quickly grew to be the fifth largest city in the Gas Belt. (Courtesy Elwood Public Library.)

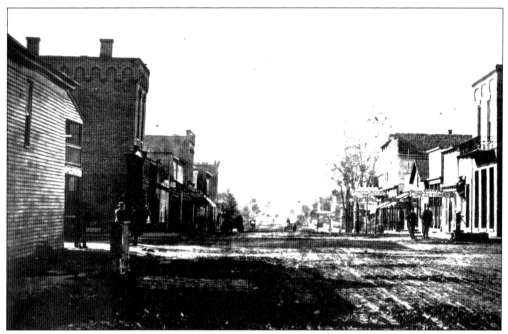

ANDERSON STREET. Downtown Elwood's Anderson Street is seen here just before the prosperity of the Gas Boom. The unpaved roadway is lined with a few small business blocks. (Courtesy Elwood Public Library.)

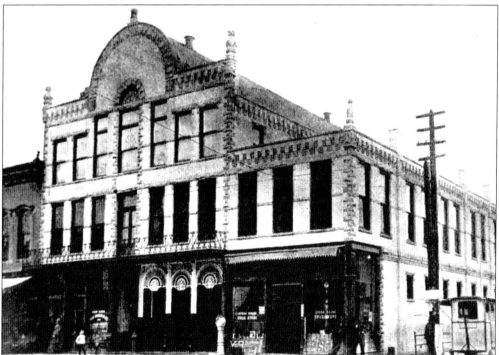

DEHORITY AND HECK OPERA HOUSE. Residents of Elwood were provided with an opera house not unlike those found in the larger county seats. It was located in this building, constructed by the Dehority and Heck families. (Courtesy Elwood Public Library.)

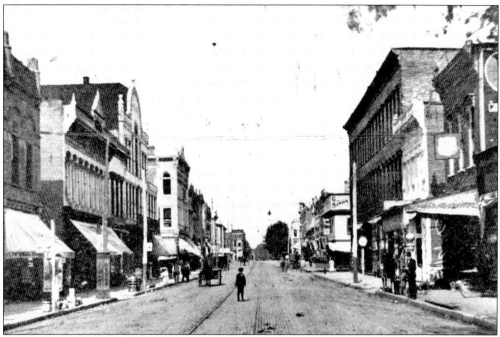

ANDERSON STREET. By the end of the Gas Boom, Anderson Street had been paved and lined with more substantial brick business blocks. (Courtesy Elwood Public Library.)

CARBARN AND LIGHT STATION. Industrial investment and rapid population growth enabled Elwood to enjoy a number of improvements. In this image, the Elwood Electric Street Railway Company's new power and light station and carbarn near completion in 1893. (Courtesy Elwood Public Library.)

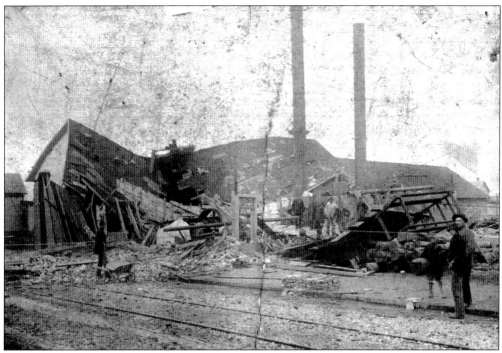

NATURAL GAS EXPLOSION. Occasionally, the exploitation of natural gas led to disaster. On November 29, 1893, a leaking gas main caused a massive natural gas explosion that destroyed the new power and light station and carbarn. These two photographs reveal the resulting rubble. (Courtesy Elwood Public Library.)

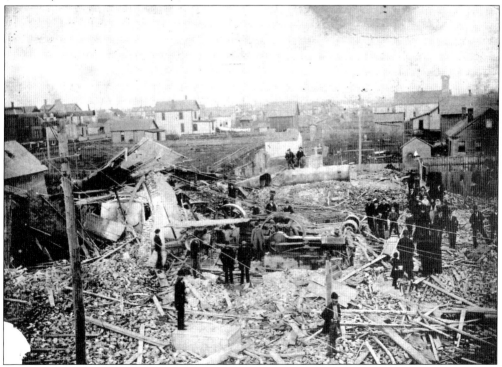

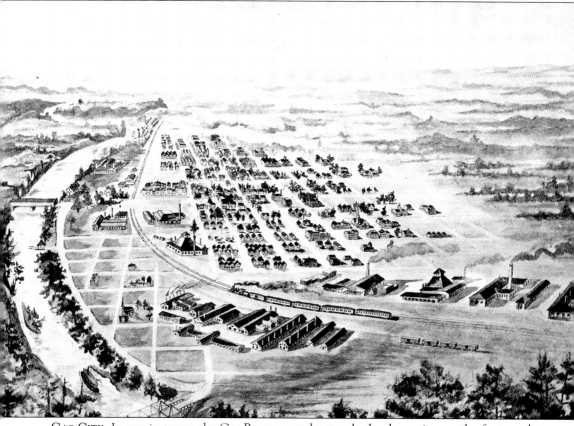

GAS CITY. In one instance, the Gas Boom caused not only the dramatic growth of a town but also the change of its name. Located in the center of Grant County, the small town of Harrisburg had 145 residents in 1890. Two years later, Gas Boom promotion struck. The Seiberling brothers of Kokomo joined with John E. Miller of the Pennsylvania Railroad to form the Gas City Land Company. They bought up 1,200 acres of real estate around Harrisburg and platted out a substantially larger community. The town was renamed Gas City, and offers of free land and gas for industrialists were issued. (Courtesy Gas City Museum.)

**OFFICES OF GAS CITY LAND COMPANY.** This collage shows the Gas City Land Company offices, with a flambeau placed prominently in the center. (Courtesy Gas City Museum.)

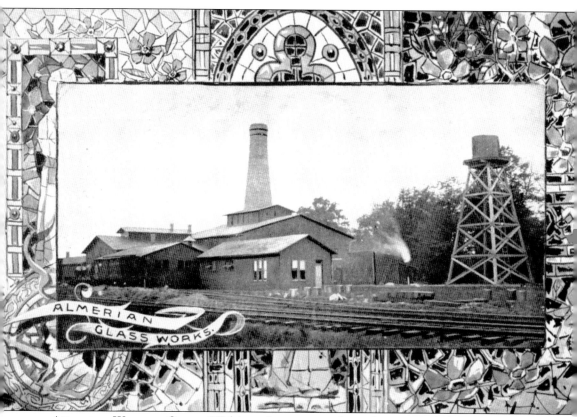

ALMERIAN WINDOW GLASS. Within a short time, industrialists responded to Gas City. The Almerian Glass Works was the first company to establish itself there, only one week after the Gas City Land Company was organized. American Window Glass and Thompson and Company soon followed with new plants. (Courtesy Gas City Museum.)

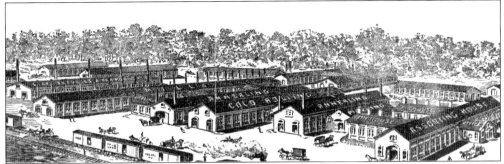

E. Morewood Tin Plate Company. In 1890, E. Morewood and Company opened a massive tin-plate factory in Gas City. Claiming to be the largest in the world, the plant covered 52 acres. This company later became part of American Tin Plate, a trust that also operated plants in Elwood and Anderson. (Courtesy Gas City Museum.)

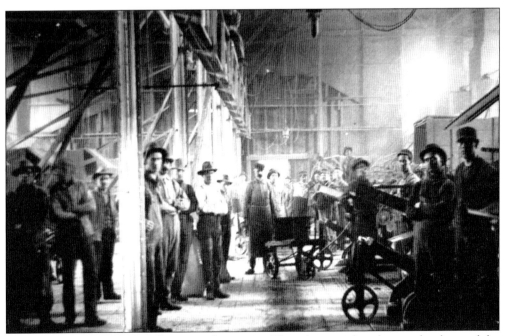

E. Morewood Tin Plate Company Interior. This photograph, taken at the dawn of the 20th century, shows the dark interior of the E. Morewood plant. (Courtesy Gas City Museum.)

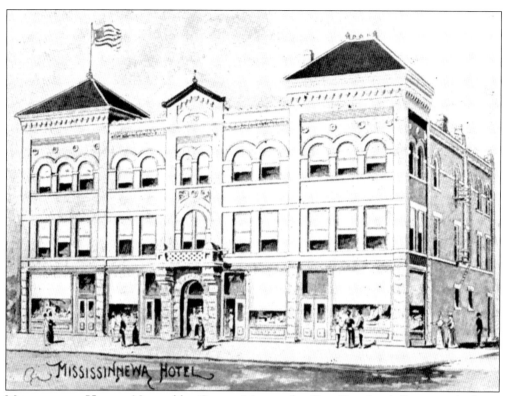

MISSISSINEWA HOTEL. Not unlike George Mason, the Gas City Land Company built an impressive hotel to house prospective industrialists. The Mississinewa Hotel was an imposing brick Romanesque structure costing $40,000. (Courtesy Gas City Museum.)

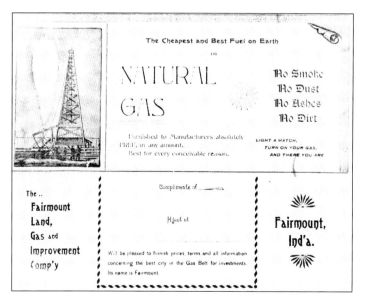

FAIRMOUNT LAND IMPROVEMENT COMPANY. Another small community affected by the boom was Fairmount. Local boomers organized the Fairmount Land Improvement Company and used advertisements such as this to promote the wonders of natural gas as a fuel for industry. (Courtesy Fairmount Historical Museum.)

**JUMBO.** This famed Fairmount gas well was nicknamed "Jumbo" after the circus elephant. (Courtesy Fairmount Historical Museum.)

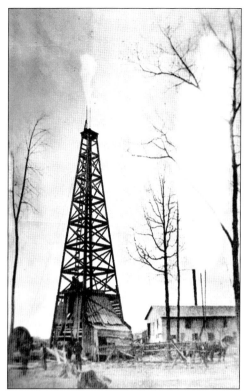

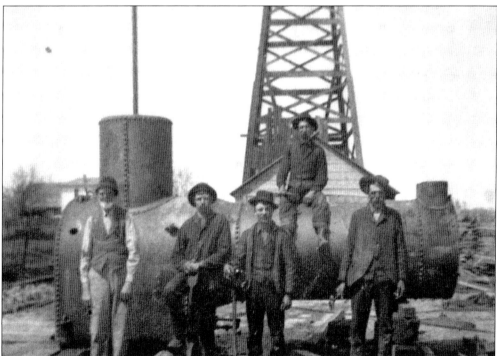

**BY THE WELL.** Here, a group of workers poses in front of a Fairmount gas well. (Courtesy Fairmount Historical Museum.)

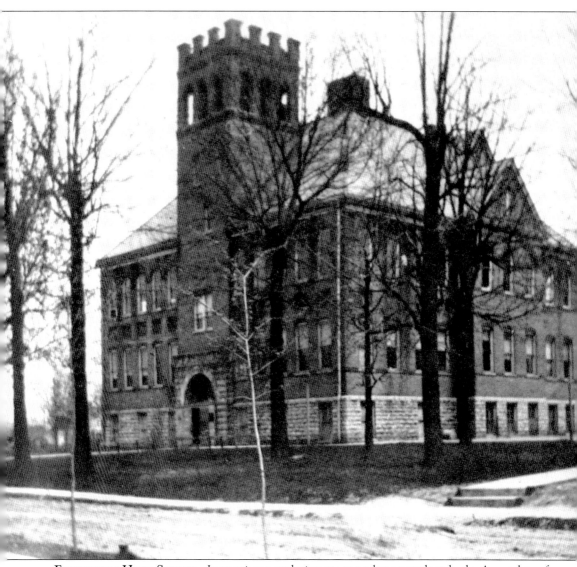

**FAIRMOUNT HIGH SCHOOL.** Increasing population meant a larger student body. A number of Romanesque schools were built in many of the smaller communities, including the high school in Fairmount, later famous as the school attended by Hollywood legend James Dean. (Courtesy Fairmount Historical Museum.)

# Seven
# THE SECOND WAVE

As every small town learned promotional techniques and began to outbid others in the inducements offered to outside industrialists, the established Gas Boom cities of Muncie, Anderson, Marion, and Kokomo found themselves pressed to maintain their rates of growth. In addition, the economic panic of 1893, although cushioned somewhat by the low cost of fuel in Indiana, caused several Gas Belt banks and factories to close or suffer losses. Each of the four cities responded forcefully to these challenges to its economic dominance.

The late 1890s saw a second wave of extravagant promotions and incentives, as the communities vied for their share of developments. Local businessmen and "boomers" organized new companies to offer incentives and lure industrialists. After an initial bubble in real-estate booming burst, land speculation was no longer a major activity. However, new industrialists still found themselves with offers of free gas, land, and cash.

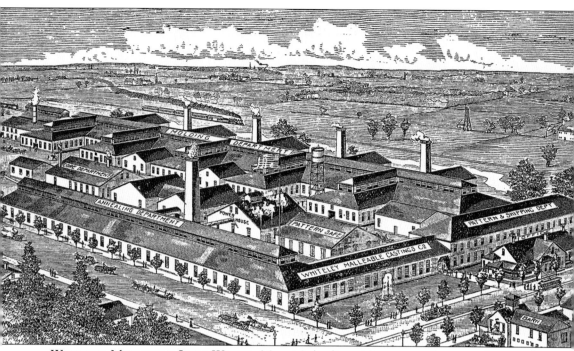

WHITELEY MALLEABLE IRON WORKS. Muncie's leading citizens were determined not to be overshadowed by the new competition. James Boyce and George F. McCulloch led other businessmen in forming the Muncie Citizens Enterprise Company in 1891 as a fund-raising organization for promoting the city. The Enterprise Company was successful in attracting four large iron, steel, and machinery factories during 1892 and 1893. These included the Whitely Malleable Iron Works, which located on Wysor Heights, north of downtown. The artist included a number of gas and oil derricks in the background of this mid-1890s rendering. (Courtesy Indiana State Library.)

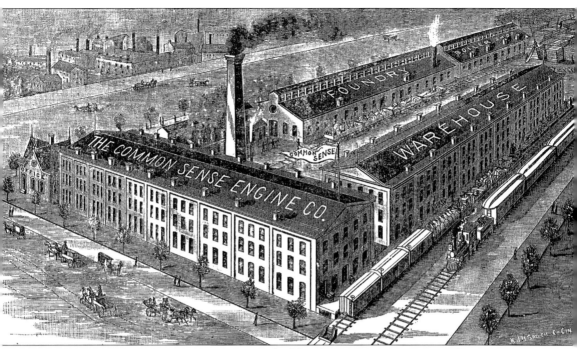

**COMMON SENSE ENGINE COMPANY.** Approached by the Enterprise Company, the Common Sense Engine Company came to Muncie from Springfield, Ohio, attracted by the natural gas and good railroad facilities. The plant's principal product was the Champion corn planter, advertised as "the farmer's favorite." (Courtesy Indiana State Library.)

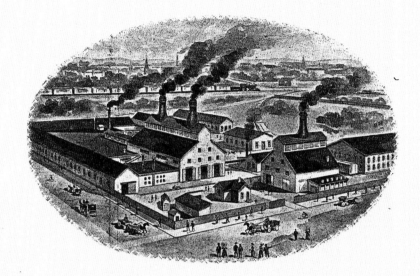

MUNCIE GLASS COMPANY. The Enterprise Company also lured a new glass manufacturer—the Muncie Glass Company, which located in southwestern Muncie in a platted development known as Winton Place. The company specialized in flint prescription ware. (Courtesy Indiana State Library.)

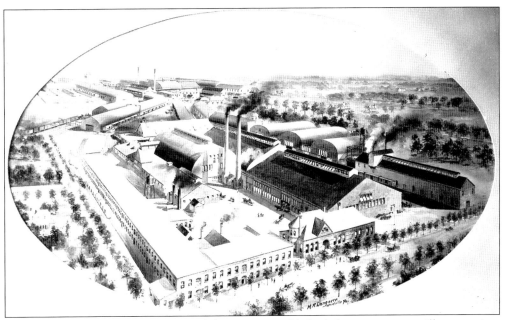

BALL BROTHERS EXPANDS. Meanwhile, many established factories were still prospering. Ball Brothers dramatically expanded its plant to accommodate demand. By the end of the boom era, the plant had grown tenfold from its original seven-acre site. (Courtesy Minnetrista Heritage Collection.)

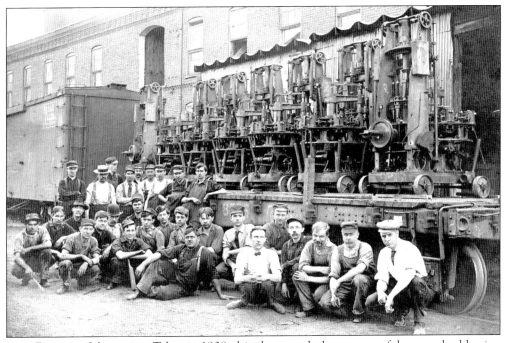

NEW BLOWING MACHINES. Taken in 1908, this photograph shows some of the new glassblowing machines used at Ball Brothers by the end of the boom era. Skilled workers had blown all of the glass when the first plants opened in the Gas Belt. Demand eventually required innovation. (Courtesy Minnetrista Heritage Collection.)

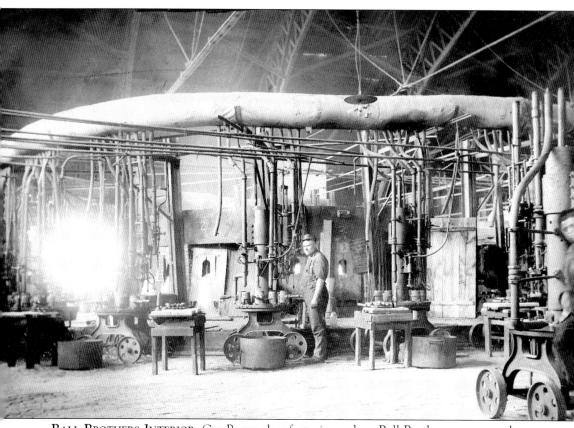

BALL BROTHERS INTERIOR. Gas Boom glass factories such as Ball Brothers were not pleasant environments. This 1900 image reveals a dark and crowded interior. (Courtesy Minnetrista Heritage Collection.)

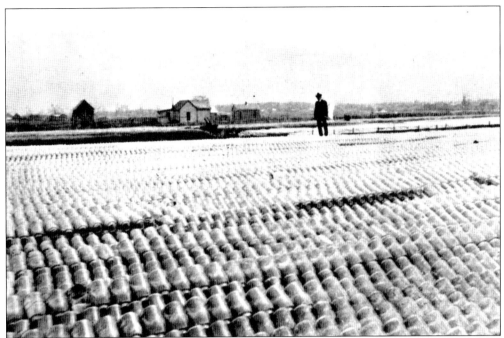

BALL JARS IN FIELD. During the non-canning season, Ball Brothers would produce more mason jars than could be stored in the warehouses. In this c. 1900 view, thousands of jars sit outdoors in a field as a temporary storage solution. By the end of the boom, Ball Brothers was producing 60 million jars a year as the largest fruit jar manufacturer in the world. (Courtesy Minnetrista Heritage Collection.)

GLASS ART. Besides items like window glass, lamp chimneys, and canning jars, glass workers produced novelty objects. This 1905 photograph shows a Bo-peep cane produced at Ball Brothers. (Courtesy Minnetrista Heritage Collection.)

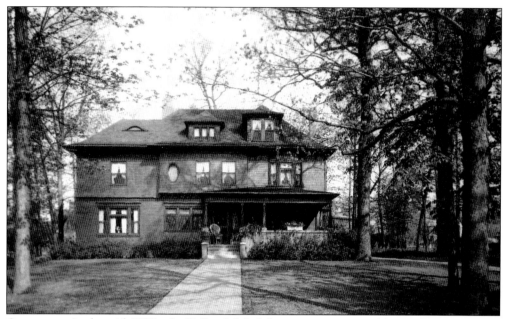

**OAKHURST.** In the mid-1890s, the Balls solidified their commitment to Muncie by constructing an avenue of elaborate homes on the White River, north of downtown Muncie. Each brother's house reflected a different taste in architecture. The Frank C. Ball home was originally built in the Colonial style before its 1902 neoclassical enlargement. George A. Ball constructed his house, known as Oakhurst, in the Shingle style. Featuring sides covered with stained wood shingles, it was completed in 1894. (Courtesy Minnetrista Heritage Collection.)

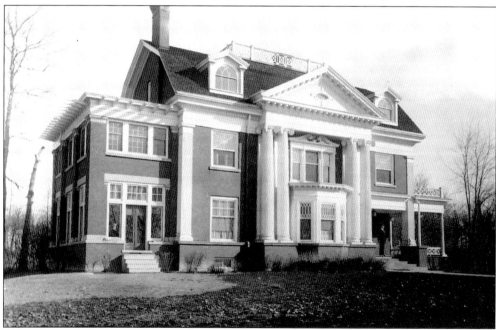

**MAPLEWOOD.** William C. Ball chose a grand version of the Colonial style for his house, seen here. Known as Maplewood, it was begun in 1897. (Courtesy Minnetrista Heritage Collection.)

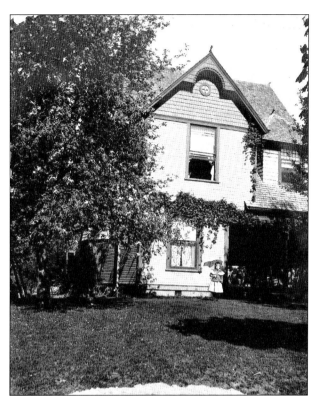

**L. L. BALL HOME.** When Lucius Ball moved to Minnetrista, he purchased an existing frame house (right), which had been at the site since 1875. In 1910, he greatly remodeled it into a Colonial-style structure (below). (Courtesy Minnetrista Heritage Collection.)

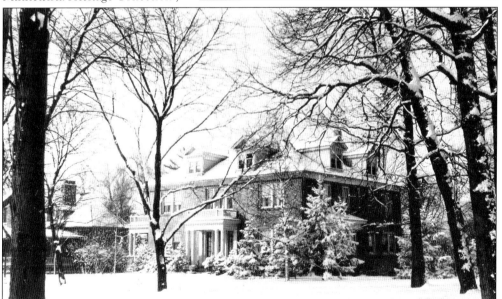

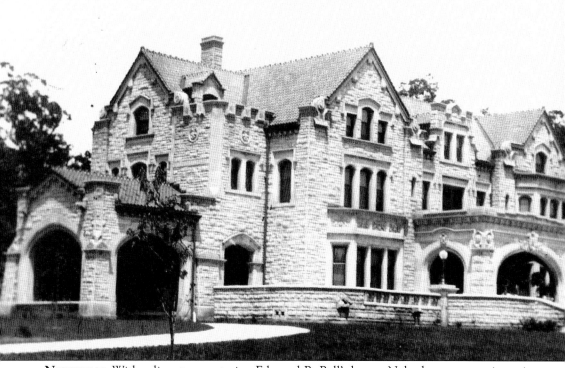

**NEBOSHAM.** With a limestone exterior, Edmund B. Ball's home, Nebosham, was an imposing Gothic and Tudor structure. Edmund was the last brother to build at Minnetrista, his home being completed in 1907. (Courtesy Minnetrista Heritage Collection.)

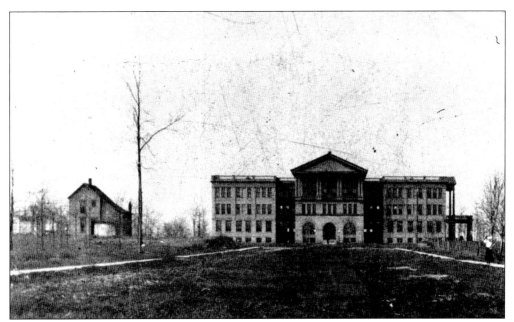

EASTERN INDIANA NORMAL UNIVERSITY. In the late 1890s, Muncie sought a university. Local investors offered to erect a building for the institution if the public would buy most of the lots in an adjacent real-estate subdivision. In 1899, the Eastern Indiana Normal University opened in this yellow brick neoclassical structure. (Courtesy Archives and Special Collections, Bracken Library, Ball State University.)

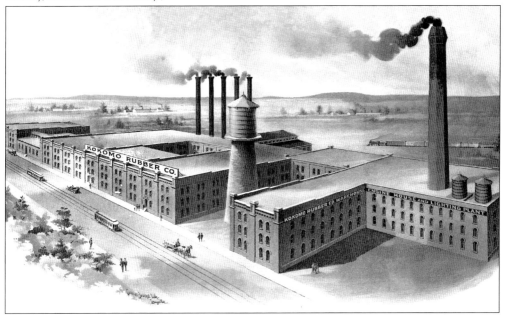

KOKOMO RUBBER. In Kokomo, businessmen organized the Kokomo Enterprise Company and promoted the availability of a free natural gas line for new manufacturers. Gas would be supplied by a trust elected by city businessmen. The company was successful in attracting a variety of manufacturers, including the Kokomo Rubber Works, pictured here. (Courtesy Howard County Historical Society.)

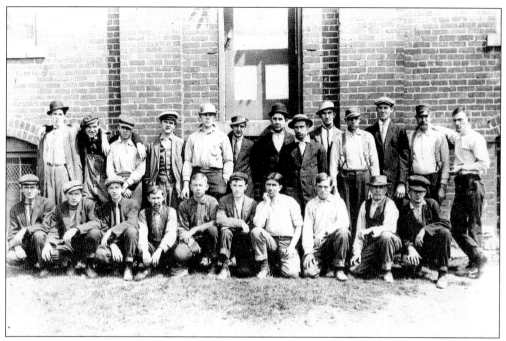

**KOKOMO RUBBER WORKERS.** A group of workers poses in front of the Kokomo Rubber plant in the late 1890s. (Courtesy Howard County Historical Society.)

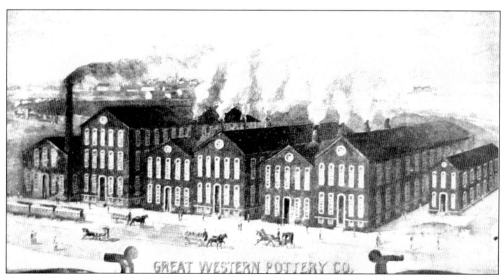

**GREAT WESTERN POTTERY WORKS.** Another sizable new plant brought to Kokomo in the 1890s by the Kokomo Enterprise Company was the Great Western Pottery Works. (Courtesy Indiana State Library.)

# *Eight*
# Boom Goes Bust

The astounding growth in industry, commerce, population, and size came at a price: depletion of the natural gas supply. Everyone was convinced that the supply was so vast that it would last decades. As a result, terrible waste was common, and conservation was not considered. Gas was offered at flat rates, and industrialists were provided with free and unlimited amounts. As early as 1889, state geologist S. S. Gorby noted in his annual report that an average of 100 million cubic feet of gas was wasted each day through uncapped wells and burning flambeaux. Throughout the 1890s, the state natural gas supervisor, E. T. J. Jordan, reported a declining gas pressure. In response, he recommended several conservation measures, including prohibitions on flambeaux and a metered system for selling gas.

Despite Jordan's warnings and conservation legislation passed by the Indiana General Assembly, gas producers and large consumers paid little heed to the alarms. Flambeaux continued to be burned three to four years after their 1891 banning. Most producers and consumers refused to give up the low prices that seemed to be the basis for the continuing commercial and industrial prosperity. Ignoring the problem was no solution. In 1901, gas pressure fell below 100 pounds, and few factories could obtain gas. Wells were abandoned. Many of the factories attracted by natural gas pulled up stakes and sought greener pastures. Several communities resembled ghost towns. The Gas Boom was over.

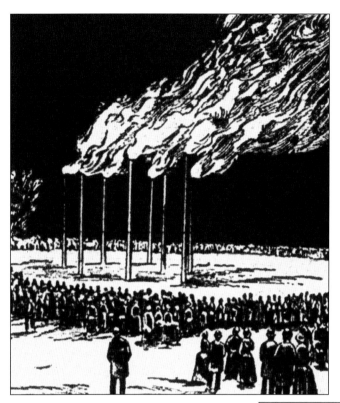

**NATURAL GAS EXPOSITION IN INDIANA.** Thinking the supply of natural gas inexhaustible, promoters did not think twice before arranging elaborate displays of flambeaux in order to show off and hopefully attract investments. These often day-and-night burnings wasted untold amounts of natural gas. Taken from the *Frank Leslie's Illustrated* of May 4, 1889, this rendering demonstrates just such an exposition of flambeaux.

**STREET CORNER FLAMBEAU.** Flambeaux were not confined to extravagant displays. Wells throughout the countryside were often left lit for days at a time. Visitors passing by on the railroads could see the whole land illuminated. In cities, it was not uncommon for flambeaux to be used to light up signs, or in this case, a street corner. (Courtesy Indiana State Library.)

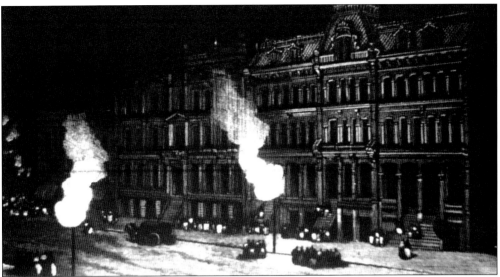

GAS PIPELINE TO INDIANAPOLIS. Cities not fortunate enough to be located within the Gas Belt were connected with supplies of gas through the construction of pipelines. Such cities included Indianapolis, Richmond, and Chicago. Because of this, gas that could have been used within the belt was lost. Wasteful displays were not unheard of even in the cities supplied by pipelines. This demonstration of flambeaux, showcased on January 19, 1889, in *Frank Leslie's Illustrated*, occurred in downtown Indianapolis.

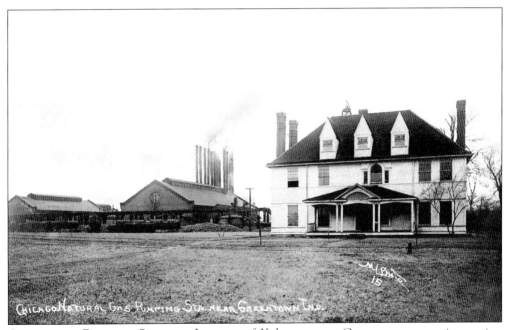

GREENTOWN PUMPING STATION. Just east of Kokomo, near Greentown, a massive station was constructed to provide pressure to pump gas to Chicago. This 1895 photograph shows the Chicago Hotel, built near the station, with the pumping station in the background. (Courtesy Howard County Historical Society.)

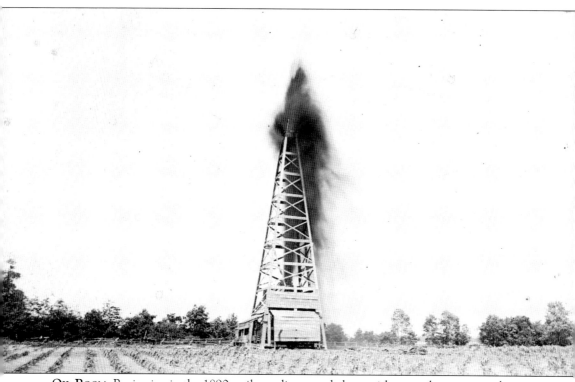

**OIL BOOM.** Beginning in the 1890s, oil was discovered along with natural gas at many locations in east-central Indiana. A rising demand for oil meant an increase in the number of oil wells. Gas well operators later complained that oil wells ruined their business. (Courtesy Minnetrista Heritage Collection.)

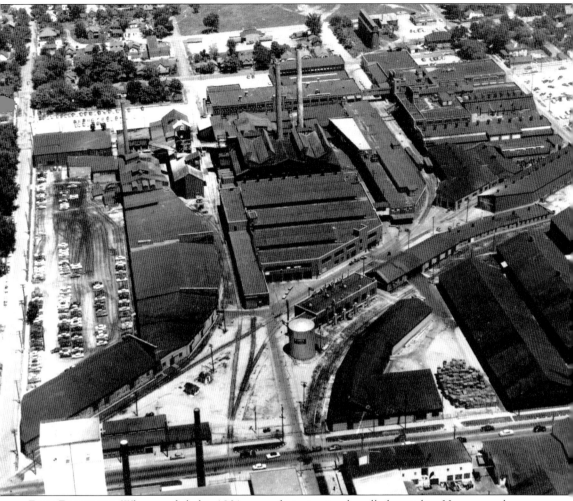

BALL BROTHERS. When gas failed in 1901, many factories simply pulled up stakes. However, others decided to stay, often unwilling to abandon their substantial investment in the area. One such factory was Ball Brothers in Muncie. Converting to manufactured gas, Ball Brothers continued to grow and prosper well into the 20th century. (Courtesy Minnetrista Heritage Collection.)

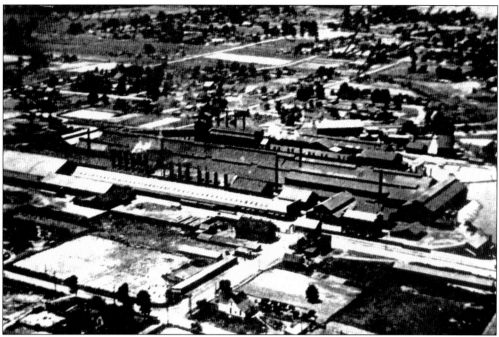

AMERICAN TIN PLATE. Now the largest tin manufacturer in the world, American Tin Plate maintained its plants in the Gas Belt for many years. This photograph shows the Elwood factory. (Courtesy Elwood Public Library.)

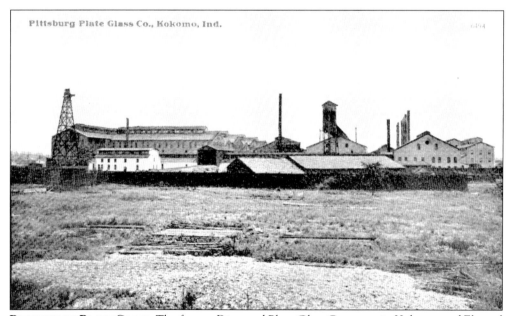

PITTSBURGH PLATE GLASS. The former Diamond Plate Glass Company in Kokomo and Elwood followed Ball Brothers by converting to alternate fuels. The Kokomo plant is pictured here in the 20th century. (Courtesy Howard County Historical Society.)

# Nine
# Legacies of the Gas Boom

By 1901, wells were failing throughout the Gas Belt. The Gas Boom was effectively over only 15 years after the "inexhaustible supply" had been discovered. Many of the factories abandoned their communities. However, the boom had left substantial infrastructure behind in the form of railroads, buildings, and workers. New factories came to replace the old. After a brief recession, the communities of the Gas Belt continued industrialization well into the 20th century. The continued growth we know today is the boom's greatest legacy.

As the 20th century wore on, much of the physical evidence left by the Gas Boom faded away. Nothing remains of the many wells, derricks, or flambeaux. Urban renewal has claimed blocks of Gas Boom–era homes and commercial buildings. A modern-day tour through the Gas Belt, though, reveals that many of the landmarks and institutions of the boom are still leaving their mark in the region.

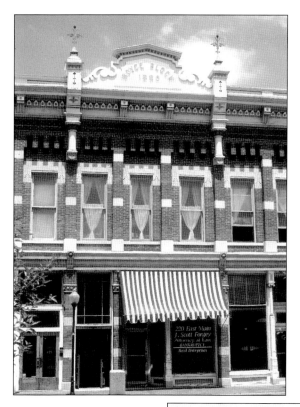

**BOYCE BLOCK.** In Muncie, the Boyce Block, a distinctive symbol of the civic work of James Boyce, still stands on Main Street. This building was the setting for many of Muncie's important development dealings. After restoration, it now houses the Civic Theater. (Photograph by James Glass.)

**ANTHONY BLOCK.** On Walnut Street, Charles Anthony's magnificent Anthony Block has not fared so well. In 1941, two-thirds of the building was demolished for a modern department store, and the corner dome was removed. The surviving section of the building has housed Pazol's Jewelers since 1936. (Photograph by David Kohrman.)

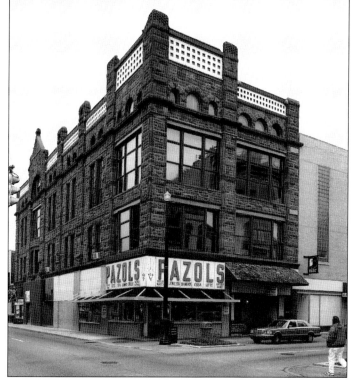

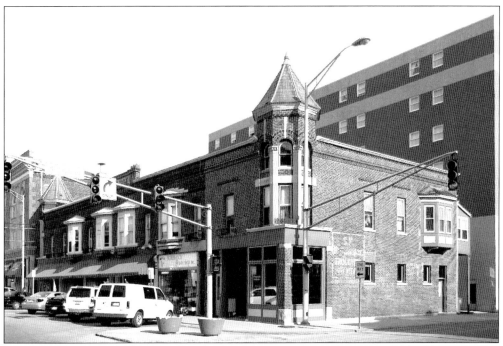

GEIGER BLOCK. A number of other downtown Gas Boom–era commercial buildings remain. The Queen Anne Geiger Block is one of them. Its detailed turrets are evidence to the prosperity of the Gas Boom in Muncie. (Photograph by David Kohrman.)

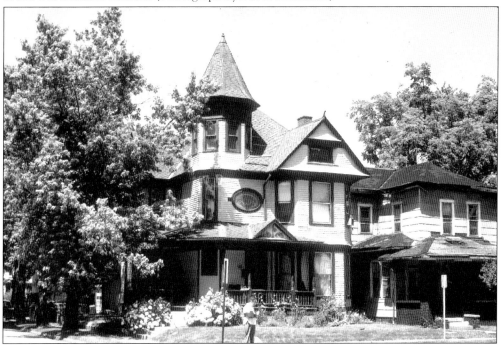

KIMBROUGH DISTRICT. Many Gas Boom–era neighborhoods in Muncie have retained their handsome homes. This view shows Main Street in the Emily Kimbrough district, still lined with ornate Queen Anne homes for the boom's prosperous citizens. (Photograph by James Glass.)

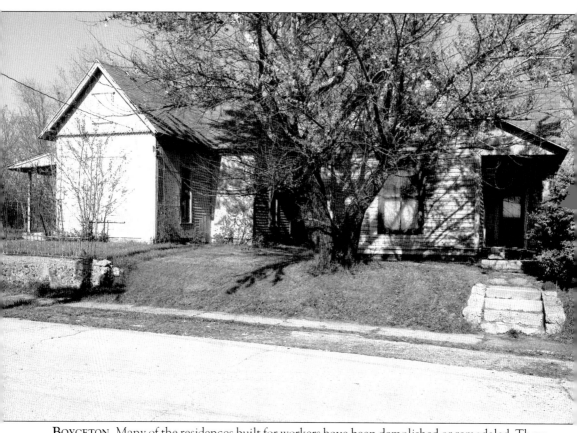

BOYCETON. Many of the residences built for workers have been demolished or remodeled. These survivors can be found on Bellaire Street in James Boyce's subdivision of Boyceton. (Photograph by David Kohrman.)

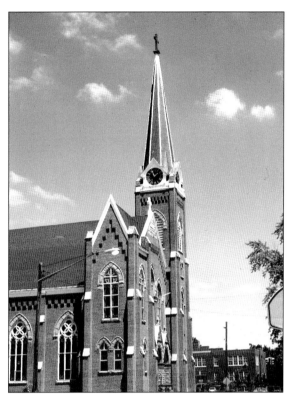

ST. LAWRENCE CHURCH. Muncie has lost most of its Gas Boom–era churches, the substantial St. Lawrence Church the exception. Built in the early 1890s, this Catholic church on East Charles Street served the immigrant workers attracted by Gas Boom factories. (Photograph by James Glass.)

FORMER SITE OF BALL BROTHERS. The Ball Brothers glass jar factory in Muncie, the largest industry resulting from the Gas Boom, was closed in 1962 and was gradually razed over the years. Despite this, the Ball family and their many philanthropies continue to benefit the city. This photograph shows the former site of the Ball plant. (Photograph by James Glass.)

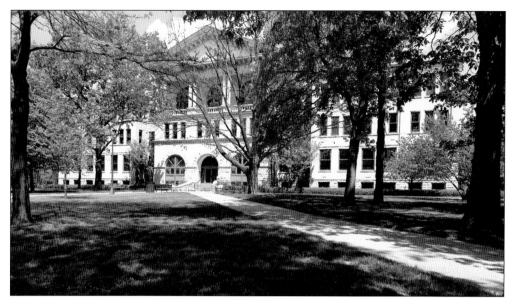

BALL STATE UNIVERSITY. Founded in 1918, Ball State University has taken over the Gas Boom–era administration building of the Eastern Indiana Normal University. Ball State, created with the assistance of the Ball brothers, has fulfilled the dream of those early promoters that Muncie be the site of a major university. (Photograph by David Kohrman.)

MINNETRISTA CULTURAL CENTER. Four of the magnificent Ball homes remain as symbols of Gas Boom wealth. Lost to fire, the Frank Ball home has been replaced by the Minnetrista Cultural Center, founded by the Ball family. Minnetrista provides community activities and exhibits that reflect the heritage of Muncie and east-central Indiana. (Photograph by David Kohrman.)

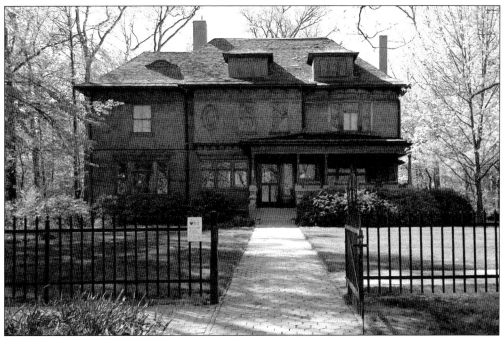

BALL HOMES. The residences of Frank Ball's brothers stand as testaments to the prosperity of the Gas Boom. The above photograph shows Oakhurst, George Ball's home. Below is a view of William C. Ball's home on Minnetrista Boulevard. (Photographs by David Kohrman.)

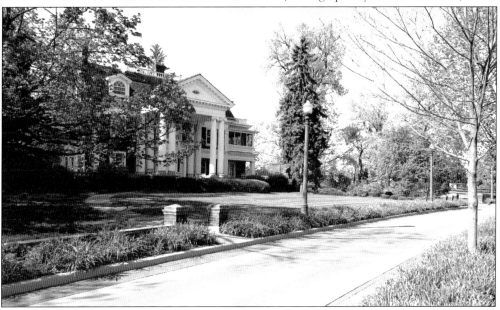

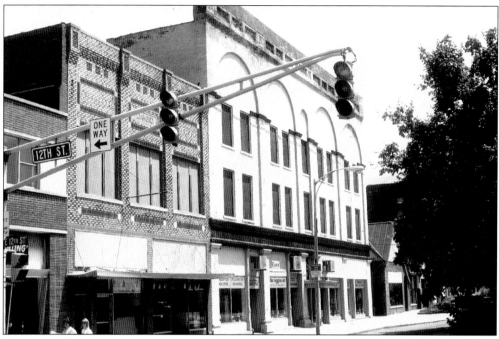

MERIDIAN STREET. A number of Gas Boom–era commercial buildings are still found along Meridian Street in downtown Anderson. The Romanesque Meridian Flats are seen here in 1997. (Photograph by James Glass.)

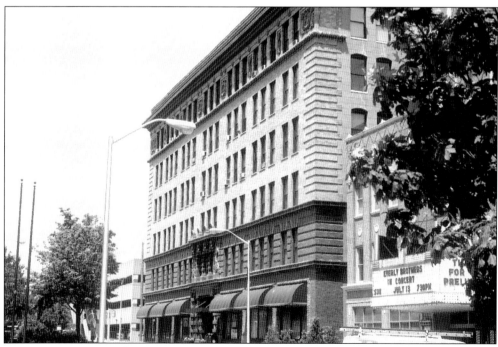

UNION BUILDING. Built in 1901 at the end of the Gas Boom, the six-story Union Building is Anderson's largest Gas Boom commercial building. It originally housed the offices of the Union Traction interurban line. (Photograph by James Glass.)

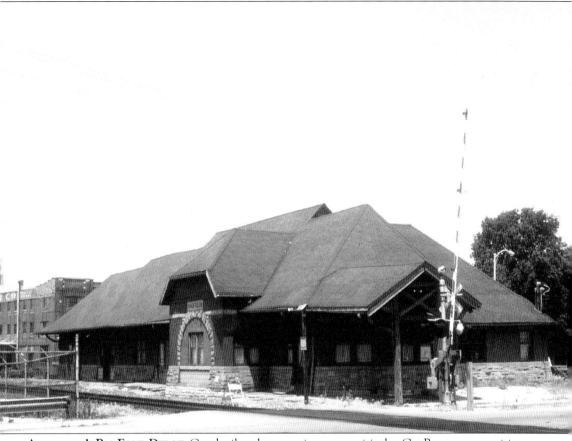

**ANDERSON'S BIG FOUR DEPOT.** Good railroad connections were critical to Gas Boom communities hoping to attract industries. The former Anderson Big Four Depot is an attractive Romanesque building symbolizing the importance of the railroads. (Photograph by James Glass.)

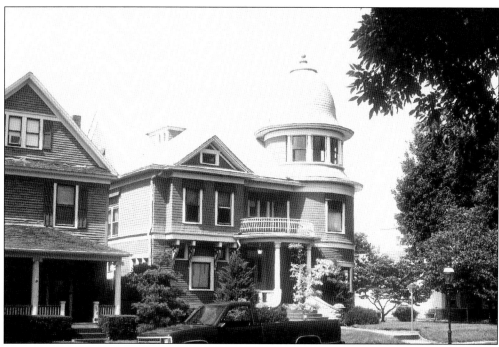

WEST EIGHTH STREET HOMES. A drive down West Eighth Street takes one past many of Anderson's Gas Boom–era Queen Anne homes. (Photograph by James Glass.)

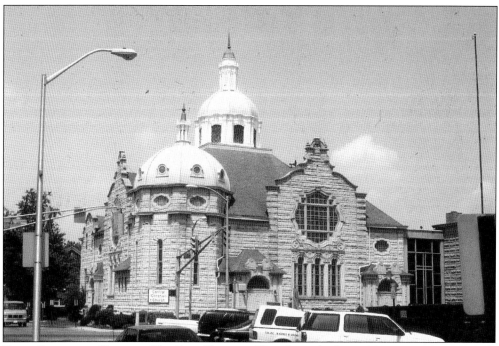

FIRST CHRISTIAN CHURCH. The First Christian Church was built in 1899 in an ornate Spanish Churrigueresque design. One of the more lavish Gas Boom churches, it can still be found at Tenth Street and Jackson. (Photograph by James Glass.)

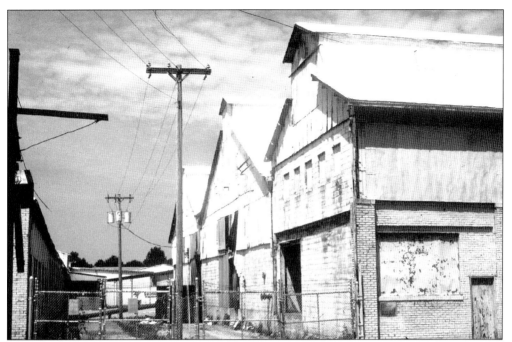

**AMERICAN WIRE AND NAIL.** Bits of Anderson's Gas Boom industry are still in existence. Remnants of the American Wire and Nail complex can be found at Locust and Eighteenth Street. (Photograph by James Glass.)

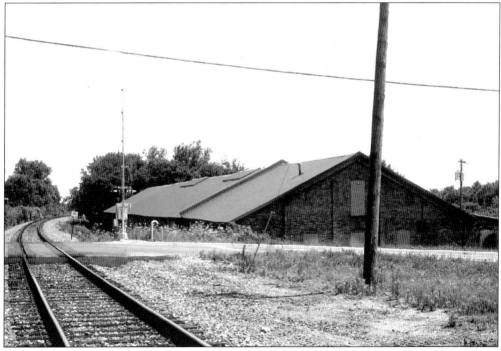

**DIAMOND PAPER COMPANY.** The warehouse and paper mill of the Diamond Paper Company survive at Twenty-second Street and Park Avenue. (Photograph by James Glass.)

KOKOMO CITY HALL. Kokomo's 1893 city hall is still impressive. Municipal offices have since moved to larger quarters. Fortunately, the Gas Boom building has been adaptively reused as business offices. (Photograph by David Kohrman.)

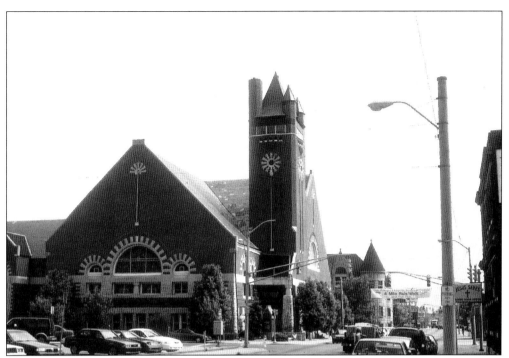

**GRACE UNITED METHODIST CHURCH.** This house of worship stands as a fine example of the Gas Boom's Romanesque church architecture in downtown Kokomo. (Photograph by James Glass.)

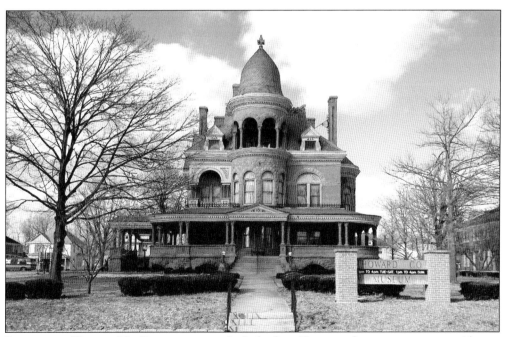

**SEIBERLING HOUSE.** The Romanesque-style Seiberling House no longer serves as a residence. Today, it is open to the public as a museum run by the Howard County Historical Society. (Photograph by David Kohrman.)

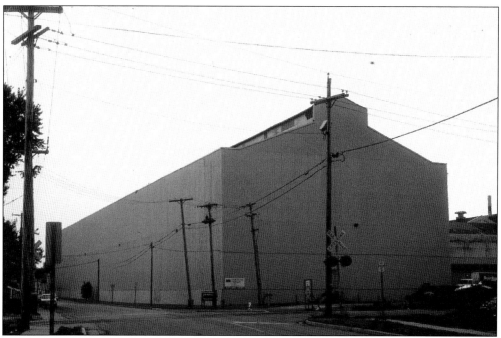

**PITTSBURGH PLATE GLASS.** Pittsburgh Plate Glass rebuilt much of the old Diamond Plate Glass plant in 1908. The large brick complex remained a glass factory well after the boom had ended. These buildings remain, just southeast of downtown Kokomo. (Photograph by James Glass.)

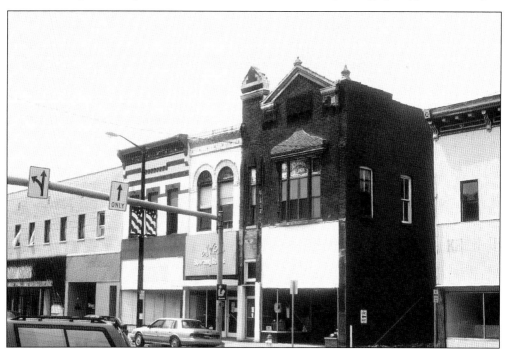

**MARION'S COURTHOUSE SQUARE.** In Marion, much of this square, including the 1880s courthouse, survives into the present day. This 1997 photograph reveals a number of Gas Boom–era commercial buildings on the square. (Photograph by James Glass.)

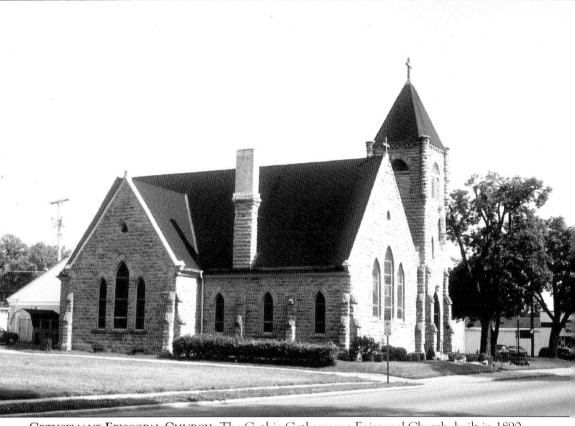

**GETHSEMANE EPISCOPAL CHURCH.** The Gothic Gethsemane Episcopal Church, built in 1890, was one of Marion's imposing Gas Boom churches. It fortunately survives and continues to serve a congregation. (Photograph by James Glass.)

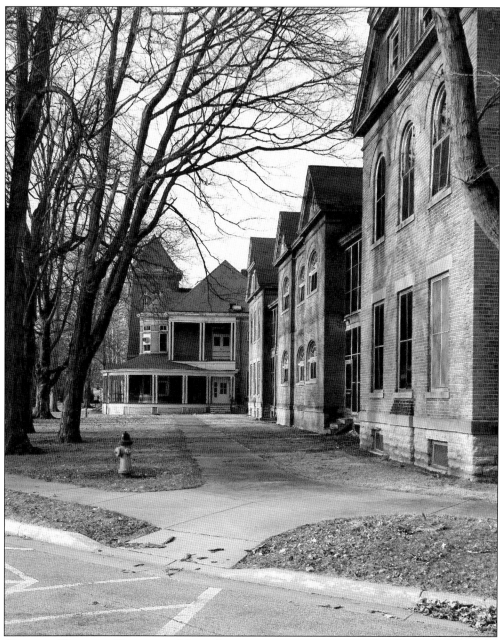

CENTRAL HOSPITAL BUILDING. Marion's most impressive surviving Gas Boom legacy is the National Home for Disabled Volunteer Soldiers. The grounds of the former home are now occupied by a VA hospital. However, the historic Romanesque structures have been vacated. This photograph shows the old Central Hospital Building. (Photograph by David Kohrman.)

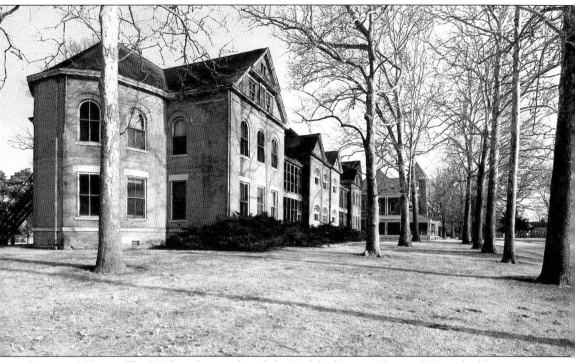

**SOLDIERS' HOME.** The VA has plans to demolish 18 of the historic National Home buildings in the near future, including those dating to the Gas Boom. The Historic Landmarks Foundation of Indiana has placed these structures on its annual Ten Most Endangered Landmarks of Indiana list since 2004. (Photograph by David Kohrman.)

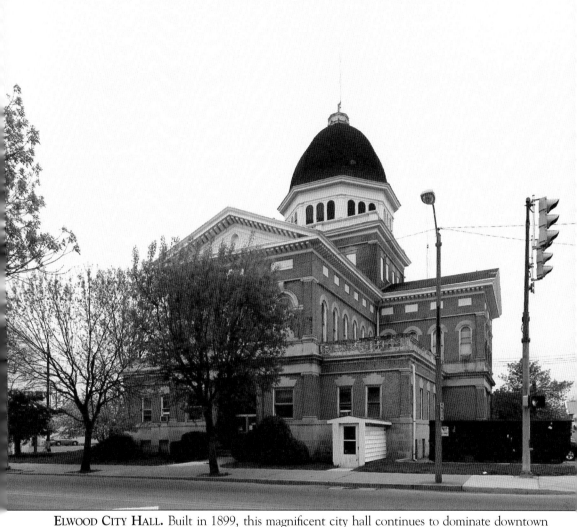

ELWOOD CITY HALL. Built in 1899, this magnificent city hall continues to dominate downtown Elwood. However, like Kokomo's Gas Boom–era city hall, the building is not serving its original function. Currently vacant, it is in danger of being demolished. (Photograph by David Kohrman.)

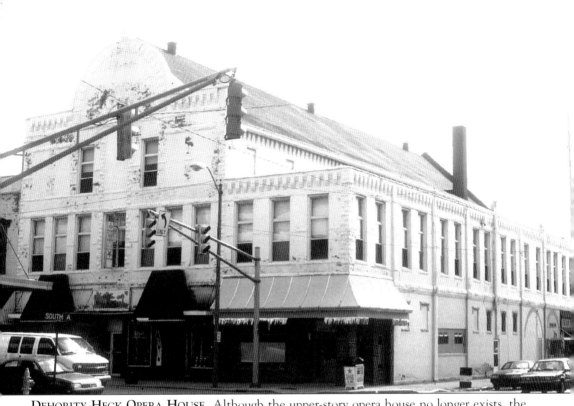

**DEHORITY-HECK OPERA HOUSE.** Although the upper-story opera house no longer exists, the building that contained the Dehority-Heck Opera House still stands in downtown Elwood and is seeking new uses. (Photograph by James Glass.)

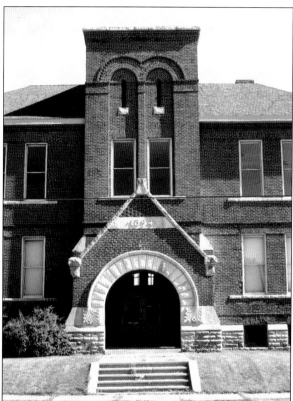

WASHINGTON SCHOOL. Built in 1894, the former Washington School is the last surviving Romanesque grade school in Elwood. When this photograph was taken in 1997, the building was vacant. (Photograph by James Glass.)

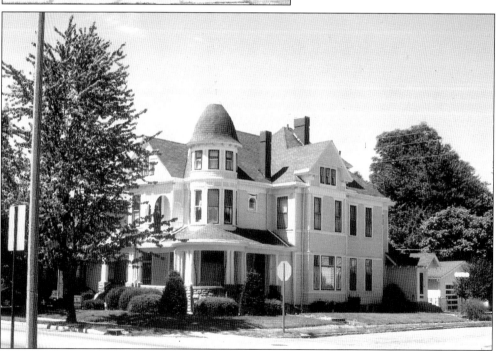

QUEEN ANNES. Many Queen Anne homes, such as these on Anderson Street, remain, signifying the finest Gas Boom architecture. (Photograph by James Glass.)

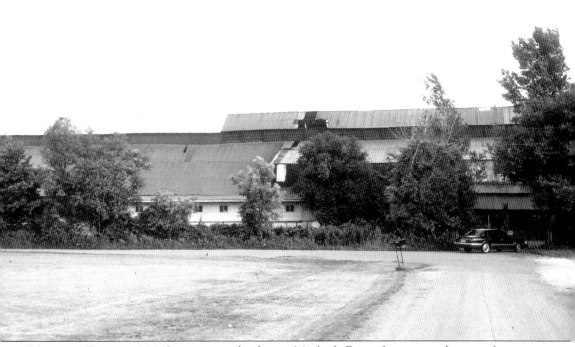

**MACBETH-EVANS, 1997.** Less ornate, the former Macbeth-Evans factory stands in northwest Elwood as the last surviving corrugated-iron plant in the Gas Belt. After it closed in 1938, various industrial firms used the plant. In 1997, at the time of this photograph, the building was being used for storage. (Photograph by James Glass.)

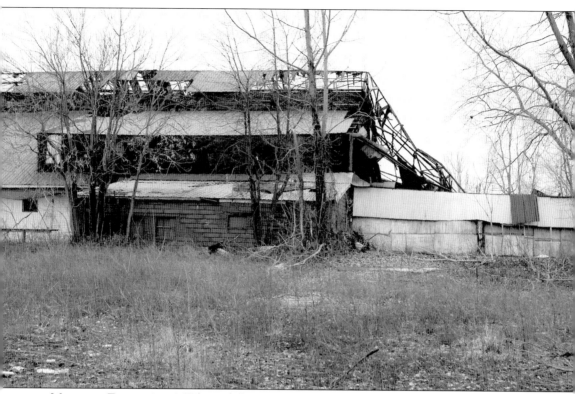

MACBETH-EVANS, 2005. What a difference eight years makes. By 2005, much of the corrugated roof had fallen away, and a section of the furnace building had collapsed. Sadly, this rare Gas Boom artifact does not have much more time. (Photograph by David Kohrman.)

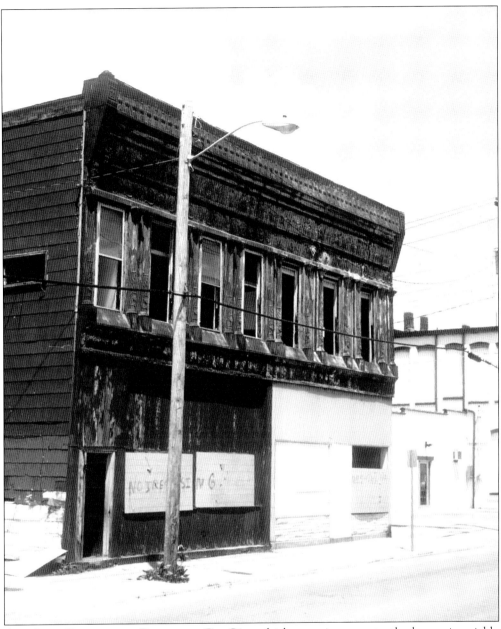

GAS CITY COMMERCIAL BUILDING. Gas City, which owes its name to the boom, is quickly losing its Gas Boom landmarks. This downtown commercial building was demolished in 1997. (Photograph by James Glass.)

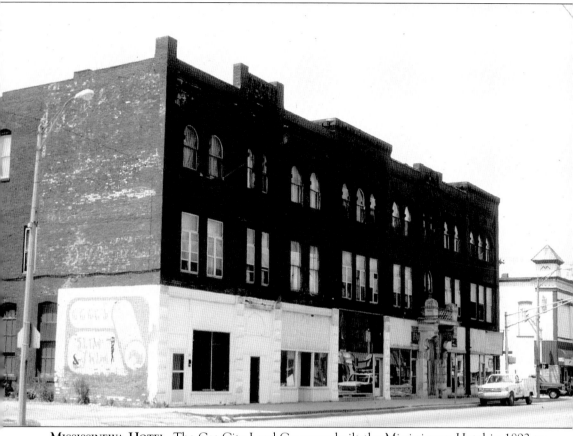

**MISSISSINEWA HOTEL.** The Gas City Land Company built the Mississinewa Hotel in 1892 to house visiting capitalists. It was in dire condition when this photograph was taken in 1997. (Photograph by James Glass.)

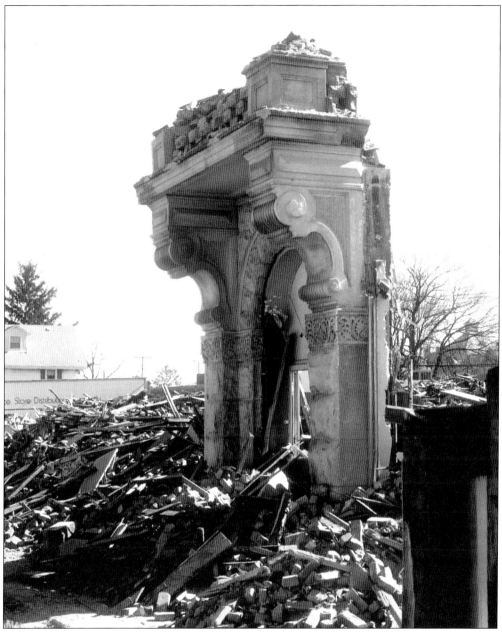

DEMOLITION OF THE MISSISSINEWA HOTEL. By 1998, the Mississinewa Hotel had become a pile of rubble. In this image, only the ornate stone entrance remains. (Photograph by James Glass.)

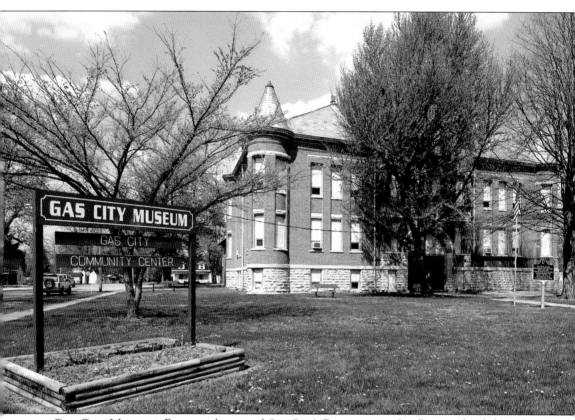

GAS CITY MUSEUM. Fortunately, two of Gas City's Romanesque Gas Boom schools have been preserved. The West Side School, seen here, houses the Gas City Museum. (Photograph by David Kohrman.)

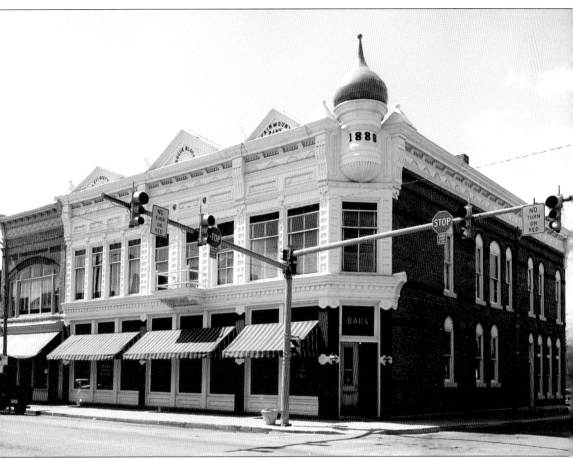

BOGUE BLOCK. Nearby Fairmount has retained much of its Gas Boom heritage. The elegant Bogue Block remains one of the finest commercial buildings in the city and has contained a bank for over a century. (Photograph by David Kohrman.)

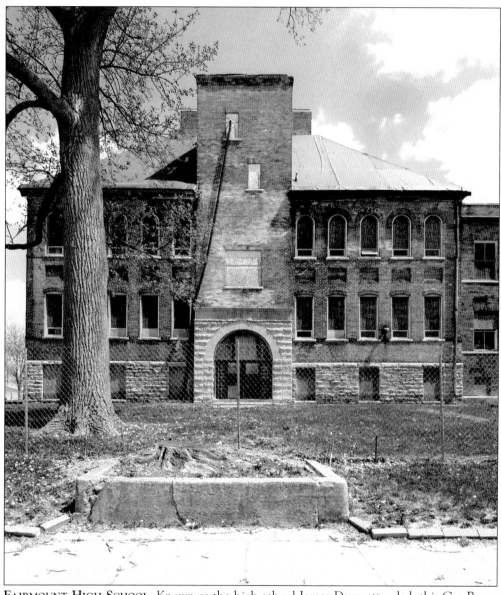
FAIRMOUNT HIGH SCHOOL. Known as the high school James Dean attended, this Gas Boom building is currently vacant but will hopefully survive. (Photograph by David Kohrman.)

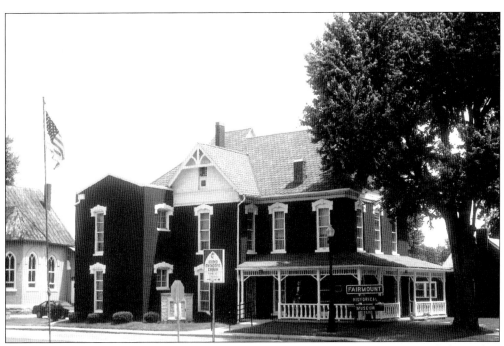

**FAIRMOUNT HISTORICAL MUSEUM.** The Fairmount Historical Museum is currently housed in this handsome Queen Anne–style Gas Boom residence on East Washington Street. (Photograph by James Glass.)

**BLACKFORD COUNTY COURTHOUSE.** The small county seat community of Hartford City retains its Gas Boom courthouse. The yellow limestone Richardson Romanesque building is perhaps the most glorious courthouse of the era. (Photograph by James Glass.)

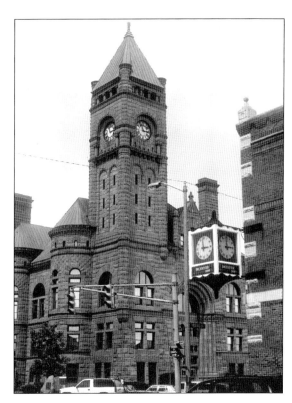

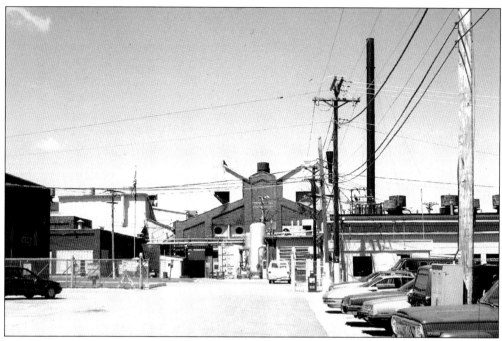

**DUNKIRK'S GLASS FACTORIES.** Dunkirk, in Jay County, is the home of some of the last operating Gas Boom–era glass factories. Above, the Indiana Glass Company is now closed. The St. Gobain plant, below, manufactures glass bottles. (Photographs by James Glass.)

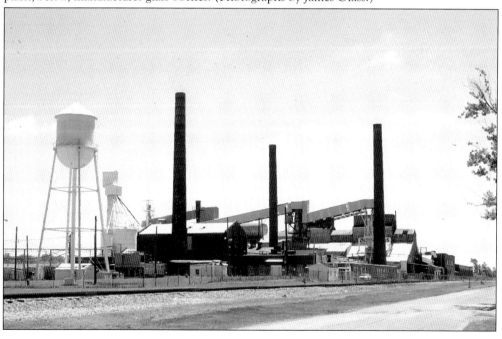

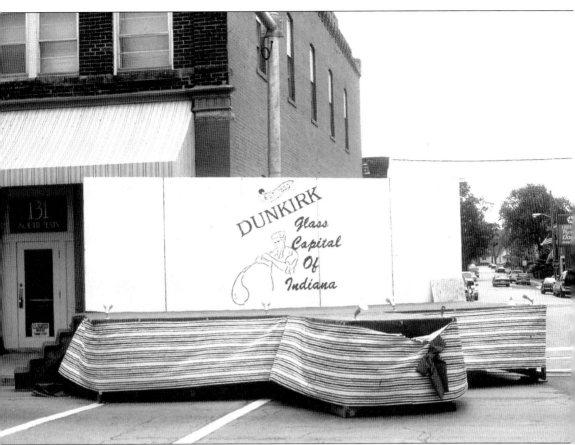

**GLASS DAYS FESTIVAL.** Dunkirk honors its glass-manufacturing heritage with an annual Glass Days Festival in June. (Photograph by James Glass.)

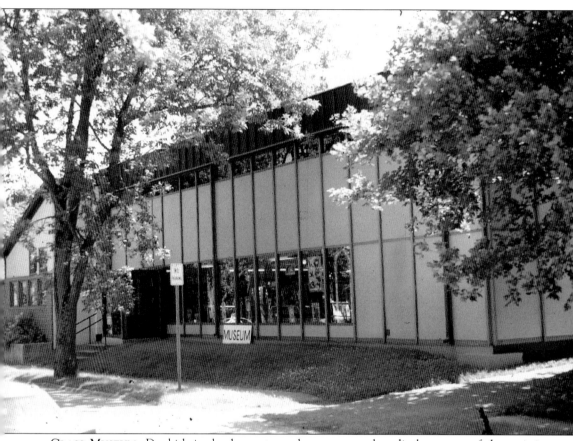

GLASS MUSEUM. Dunkirk is also home to a glass museum that displays some of the artistic pieces produced by glass manufacturers. (Photograph by James Glass.)